DUBLIN PUBS

PAT DARGAN

AMBERLEY

First published 2018

Amberley Publishing
The Hill, Stroud
Gloucestershire, GL5 4EP

www.amberley-books.com

Copyright © Pat Dargan, 2018

The right of Pat Dargan to be identified as
the Author of this work has been asserted in
accordance with the Copyrights, Designs and
Patents Act 1988.

ISBN 978 1 4456 8425 3 (print)
ISBN 978 1 4456 8426 0 (ebook)

British Library Cataloguing in Publication Data.
A catalogue record for this book is available from
the British Library.

Origination by Amberley Publishing.
Printed in the UK.

Contents

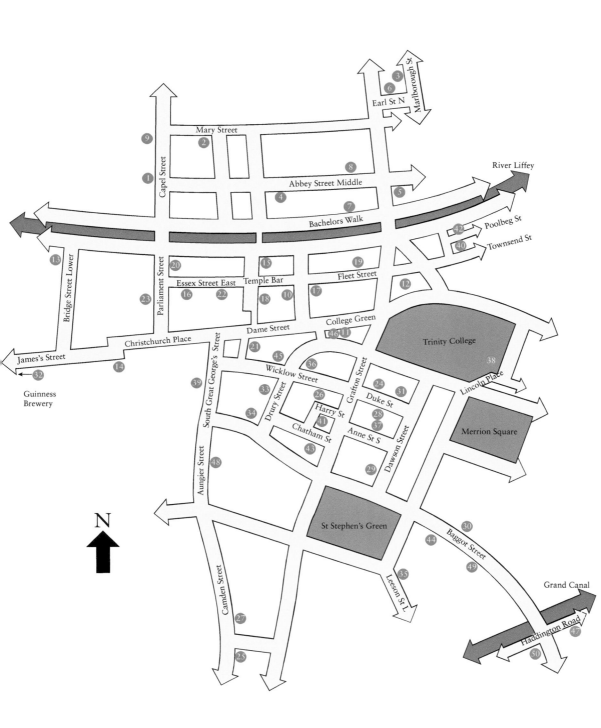

N

Key

Introduction

A good puzzle would be to cross Dublin without passing a pub.

James Joyce

Background

The pub, or 'bar' as it is commonly known in Dublin, is a premises where alcoholic beverages are available to patrons for consumption on the premises. The pub, as an Irish social institution, dates from Victorian times where men gathered together to socialise and have a drink, although some pubs provided a small private cubicle or 'snug' near the door where ladies might be discreetly served. A snug was provided with cushioned seats, partitioned off from the main bar and served through a small hatch. Fortunately a number of snugs – such as Toner's and Donny & Nesbitt's – survive intact, although they are no longer reserved for the ladies. During this period most of these pubs were inserted into the ground level of earlier buildings, although a number of totally new structures were completed, such as The Bruxells and The Bleeding Horse.

The origins of Dublin City lie in the ninth century when the city was established as a Viking settlement and spread outwards over the following medieval, Georgian, Victorian and modern periods. Today the city extends between the M50 Orbital and has a population of around 1.5 million. Within this urban area it is reckoned there are around 900 pubs, although this book focuses on fifty examples. These represent the personal choice of the writer and have been selected to offer an overview of the character and scale of the many other pubs spread around the city and reflect a visual aspect of local history. For ease of access and identification, the presented examples lie within a series of neighbourhoods that cluster around the city centre. These include the O'Connell Street, Temple Bar and St Stephen's Green neighbourhoods.

Dublin Pubs

Historically, Dublin pubs initially consisted of a large single room and an occasional snug. Today, however, all but a very few have a range of different size bars, lounges and dining facilities. The often highly decorated interior of the typical Dublin pub reflects

the application of Victorian styles and decor, while externally the fronts display a rich variety of colourful Victorian frontages that include a doorway and display windows set between slim uprights – the latter supporting a high-level crosspiece or fascia, often with the name of the owner boldly painted. Although Victorian in style and date, the elements that go to make up the Victorian pub front are often Georgian in terms of decoration. The major internal feature of the Dublin pub is the tall bar counter (often with a marble top), where the customers sit on equally tall bar stools. Behind the bar counter is the back bar, or optic display. This is a full-height panel of shelves, mirrors and backlighting that displays what the pub has to offer. Traditionally, the drinks of choice in Dublin pubs was Guinness and Irish whiskey – the black-coloured Guinness is served in a pint glass and, with its cream-coloured top, remains an iconic feature. The initial production of Guinness can be dated to 1770 when a new type of strong dark-coloured beer was introduced. This had its origins in London where it was made from roasted barley. It was called 'porter' after the Covent Garden porters with whom it became popular. Guinness began to produce a stronger version of this porter and gave it the name 'stout porter'. Eventually the word 'porter' was dropped and the brew

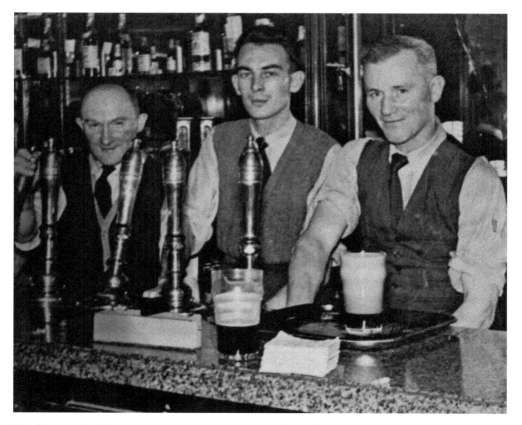

Traditional Dublin barmen *c.* 1970 serving behind the marble-topped bar, with pints of Guinness, tall-handled pumps and the back bar display.

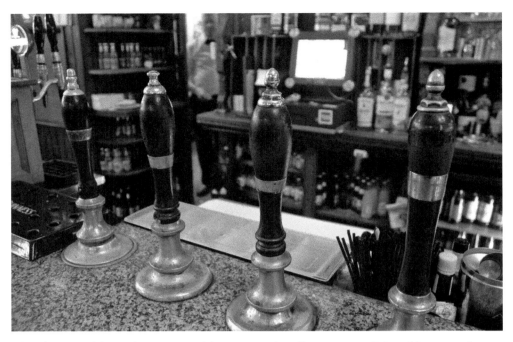

The ebony and brass bar-mounted beer pump handles are a traditional feature of some Dublin pubs.

became known simply as 'stout'. Today Guinness and whiskey remain popular, in addition to the extensive range of other beers, wines and spirits that are also available, although locally inspired craft beers are making inroads into the market. Supplies to the pubs were delivered to the pub's underground cellars, where the kegs were stored. Deliveries were made through a grill in the footpath outside the pub, which can often still be seen. From the cellar, the beer (called draft) was pumped to the bar counter where it is delivered into the patron's glass by a series of tall handpumps with ebony and brass handles – a surviving image in many Dublin pubs. The draft Guinness was served in pint or half-pint glasses, or from a bottle.

Traditionally, the Dublin barmen were dressed in a white shirt, white jacket and long white apron – all well starched. Regretfully this custom has all but died out. Another tradition that has also passed is the 'Holy Hour'. Prior to the 1980s the pubs in Dublin closed for an hour at 2.30 p.m. This allowed the barmen to go home for lunch and get back to work by 3.30 p.m. It also, of course, encouraged the patrons to return to their workplace on time. Two recent additions to the Dublin pub scene include the provision of food and music. Restaurant facilities are now part of most pubs, and the preparation and serving of food account for half the turnover. In fact, pubs that do not provide some level of food service are the exception today. In a similar way, most pubs provide some level of live music that can range from traditional Irish music to jazz, depending on the individual pub.

O'Connell Street Neighbourhood

The O'Connell Street neighbourhood includes the O'Connell Street axis, which stretches north from O'Connell Bridge over the River Liffey and includes the adjoining Abbey Street, Capel Street and Mary Street. The area suffered much damage from military action and bombardment during the Easter Rising of 1916, when many of the buildings were destroyed or badly damaged. The area has long since been rebuilt and today functions mainly as a retail and restaurant centre, with the occasional pub.

1. The Boar's Head, No. 149 Capel Street

The Boar's Head pub is positioned on the ground level of a three-storey nineteenth-century corner building that stands at the junction of Capel Street and Mary's Abbey – part of the site of the now all-but-vanished St Mary's Abbey. The surviving underground chapter house of the monastery is, fortunately, still accessible from the nearby Meetinghouse Lane, off Mary's Abbey. The black-coloured façade of the pub opens onto both streets, with the white windows divided into small square panes. Overhead, the name 'Boar's Head' is spelled out in gold letters across the black fascia. The choice of the colour black on the pub front is interesting as in the past black-painted pub fronts were seen by the Guinness Brewery as suggesting the availability of Guinness – also coloured black.

The pub is currently run by the Hourican family. Hugh Hourican was working in New York in 1994 when he learned that his uncle had decided to sell the premises. At that point the pub was known as Hourican's. When Hugh and his wife returned to Ireland they took over the pub and renamed it The Boar's Head. This name was taken from a large advertising mirror on one wall of the bar that advertised Boar's Head whisky. Since then the pub has developed a long association with sport. The pub is near Croke Park, the centre of Irish hurling and Gaelic football (GAA) and there is a tradition that after every important match the supporters congregate in The Boar's Head to celebrate. All sports are, however, catered for in the pub. Ian Woosnam used the pub as a base for interviews when he was captain of the European Ryder Cup team in 2006 and Shane Lowry presented a poster to the pub when he played in the 2015 Masters. Another patron of the pub was the snooker player Alex Higgins. Internally, the small pub has a long bar at ground level and a similar bar upstairs. The ground-floor bar counter, in particular, has a framed back bar and an overhead canopy all in dark polished wood, while the walling has a display of framed sport images and a stuffed boar's head.

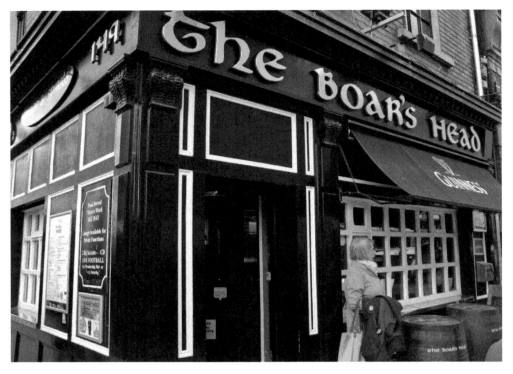

The black-coloured pub front of The Boar's Head has small white-painted square windowpanes with the name spelled out in gold letters across the black fascia.

The name of The Boar's Head pub was taken from an old mirror in the pub that advertised Boar's Head Whisky.

2. The Church, Junction of Mary Street and Jervis Street

The former St Mary's Church was designed by Sir William Robinson around 1700 and was the first Georgian-style church built in Dublin. John Wesley preached here in 1747, Arthur Guinness was married here in 1761, Theobald Wolf Tone (the Irish nationalist) was baptised here in 1763, and Jonathan Swift attended services here. By 1986 the congregation had greatly decreased and services ceased. Eleven years later the church was sold and was purchased by John Keating, who renovated the building and in 2005 reopened the church as a pub. It was named John Keating's until 2007 when it was renamed The Church. During the renovations the white rendered walls, round-headed windows and slate roof were all carefully restored and the new glass-faced cylindrical stairs, lift tower and walkway to the gallery floor was built on the Mary Street side, so that with the exception of the tower the building remains much as it did during the eighteenth century.

Internally, the regeneration produced a sumptuous rectangular double-height pub space. This includes the open ground level with a centrally arranged oval bar counter. All around, the edges of the interior are divided into seating bays by wooden columns that extend upwards to carry the wooden-panelled upper-level gallery, which sweeps around the edge of the open space. Overhead, the interior space is crowned by a moulded barrel-vaulted ceiling. Atmospherically, the interior is enhanced by the retention of the original church features, including the massive traceried east window, the organ loft and pipes, the smaller round-headed windows, and surviving family

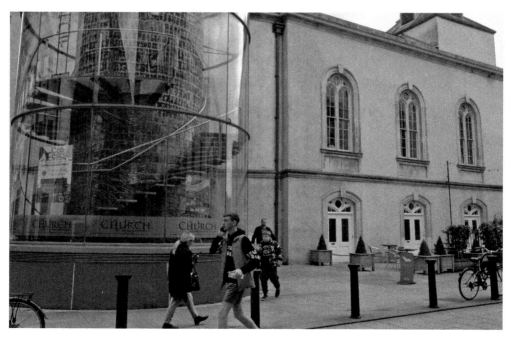

The former eighteenth-century St Mary's Church is now a pub and is an outstanding example of historic building regeneration.

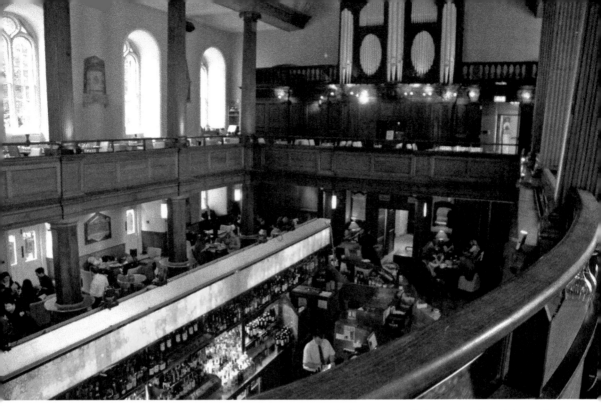

The former ecclesiastical interior space. Historical elements and the central oval bar of The Church offer a remarkable pub experience.

memorials that dot the walls. Behind the main building the churchyard has been landscaped as a public park and an attractive pub patio has been created on the far side of the building facing onto Mary Street.

3. The Confession Box, No. 88 Marlborough Street

The Confession Box is one of the smallest pubs in Dublin and is located on Marlborough Street, a short distance from St Mary's Pro-Cathedral. The building dates from around 1800 and acted as a private house where the noted scientist Dionysius Lardner and his son, the Victorian playwriter, lived. In 1890 the ground floor's interior was remodelled as a single-room pub called the Maid of Erin, which is when the Victorian-styled pub front was inserted. The curious name, the Confession Box, has its origins in the Irish War of Independence, between 1919 and 1921, when nationalist volunteers were excommunicated from the Catholic Church and denied the religious sacraments. A number of volunteers, however, including the leader, Michael Collins, were quietly given the sacraments in a corner of the pub by a sympathetic priest from the nearby Pro-Cathedral. As a result the pub became known colloquially as the Confession Box. Later the pub came into the ownership of Michael O'Flanagan and was renamed O'Flanagan's. Michael and his brother Kevin had the unusual distinction of playing against one another in the international football match between Ireland and England in 1946. Michael had been playing for the local Bohemians club and Kevin had been

playing for Arsenal. Michael got the surprise call to play in the international match as he was serving lunch in the pub. He ordered the astonished customers to drink up and leave, rushed home to collect his football boots, and went straight to Dalymount Park where the match was scheduled to play. In the event England took the honours.

In 1965 the name of the pub was formally changed to the Confession Box. Today the black rendered pub front of 1890 represents one of the icons of the Dublin Victorian pub design. The double display window and flanking doors are set between square decorated columns, with an elaborate fascia overhead. To compliment the black colour, the name, decorated columns heads, moulded sill, and decorative medallions were all skilfully picked out in gilt. Inside, the pub has a single room with an open high-level gallery reached by a wooden stairs in one corner. This was cut into the original ceiling and allows the upper-level patrons to experience the ground-level service and activity. The wooden bar counter and back bar are the principal feature of the pub. The latter has a large round-headed mirror flanked by double Georgian columns that extend upwards into the overhead gallery. Elsewhere, the painted walls display a collection of framed memorabilia relating to Michael Collins and the War of Independence.

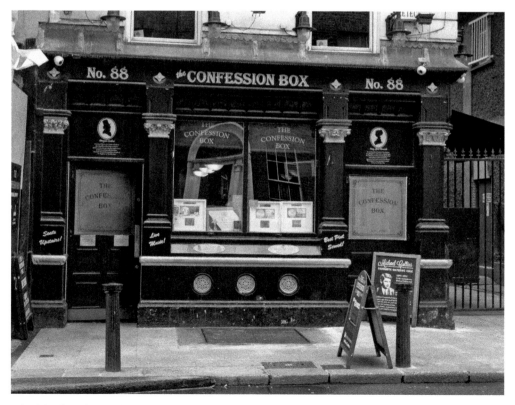

The black-coloured Victorian street front of The Confession Box with the gilt trimming is one of the highlights of Dublin's Victorian pub heritage.

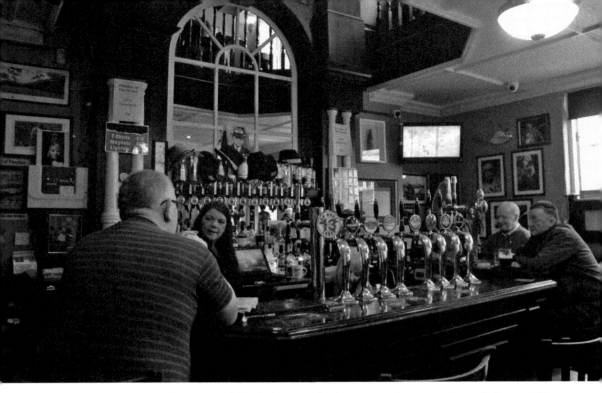

The bar counter and mirrored back bar mark the internal centrepiece of the small Confessional Box.

4. Gin Palace, No. 42 Middle Abbey Street

The Gin Palace, as the name suggests, specialised in serving the gin enthusiast within an attractive Victorian-styled pub. The pub, however, has a recent origin and dates from 2006, immediately prior to which a commercial retail premises occupied the site. The interior of the bar follows an L-shaped plan, with the main entrance on Middle Abbey Street and the toe of the 'L' opening onto to Liffey Street. The narrow, timber Middle Abbey Street front has a nineteenth-century design with a curved display window, flanked by a pair of carved entrance doors over which the moulded fascia proclaims the name and street number. The toe section of the premises opens onto Liffey Street and has a similar, but much plainer, front.

The internal arrangement of the Middle Abbey Street sector of the pub offers a rich Victorian atmosphere. This includes a patterned mosaic floor, a wooden-framed fireplace, a polished wooden bar counter with drop-down lighting globes, and carved panels that divide the interior into sections. These have intricately carved semicircular stained-glass panels, moulded cornices and curved tops. Behind the bar counter the even more elaborate back bar has brightly coloured heraldic painted mirrors, carved uprights, moulded brackets and cornices. Elsewhere, the side walling has framed and polished panelling, mirrors and an overhead moulded cornice, above which the embossed ceiling, ceiling roses and chandeliers reflect the Victorian ideal. These were all imported from a closed pub in Britain by the Fitzgerald family and reassembled in Dublin as the Gin Palace – in effect creating a Victorian pub.

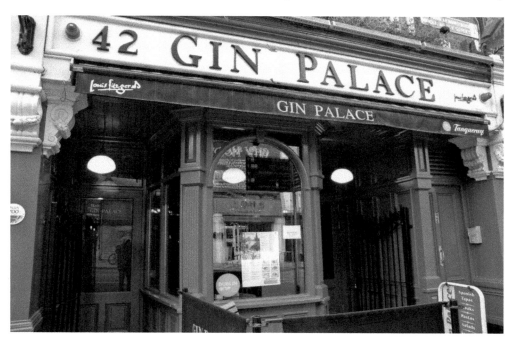

The decorated Victorian wooden pub front of the Gin Palace opens onto Middle Abbey Street.

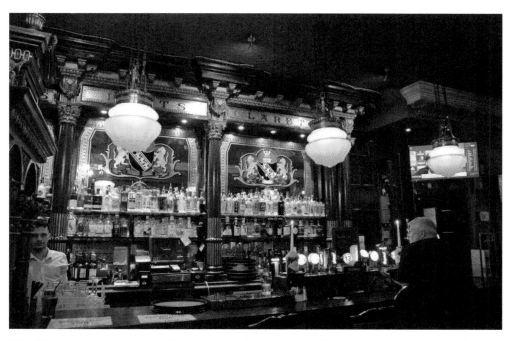

The Victorian bar area, with brightly coloured heraldic painted mirrors and framed back bar – all sourced in Britain and reassembled in the Gin Palace.

5. The Grand Central, Nos 10–11 O'Connell Street

The origins of The Grand Central can be traced back to 1824 when a house was built and leased to Francis Westley. In 1916 the premises was owned by William McCarthy, but was extensively damaged by shelling from the battleship *Helga* during the Easter Rising. The following year the Munster and Leinster Bank bought the ruin and the adjoining house premises with the view to opening a branch of the bank at the corner of Lower Abbey Street and O'Connell Street. McDonnell and Dixon were appointed architects and building work went on until the early 1920s. McDonnell's design was an impressive example of neo-Georgian architecture and survives to the present day. The Portland stone and granite building is five storeys high with round- and square-headed windows, double-height classical columns, an elaborate cornice and an attic. The entrance is on the curved corner of the building, immediately above which a miniature domed temple rises above the attic and highlights the corner position. A plaque on the O'Connell Street front notes that the first radio broadcast in Ireland was transmitted from the building by the Republican forces on 24 April during the Easter Rebellion in 1916.

Around 2001 the bank ceased to use the building and it was sold to the Fitzgerald family who remodelled the interior of the building as a pub and restaurant, with only minor changes to the layout and style of the original rotunda shaped banking hall. Today a small oval lobby provides access to the rotunda, where the dominant feature

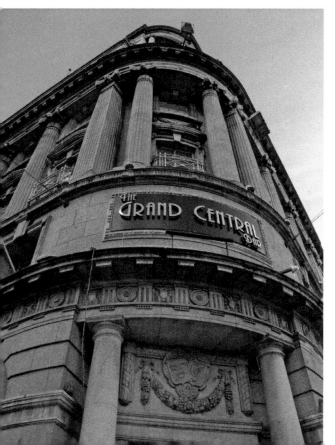

The curved landmark neo-Georgian entrance front of The Grand Central pub faces onto Lower Abbey and O'Connell streets.

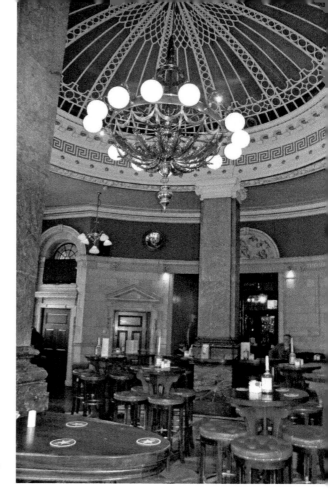

The central dramatic rotunda of The Grand Central features a glass dome, decorated cornice, marble-faced piers and a tiled floor.

is the splendid glass dome with intricate panelling, a moulded cornice and an imposing chandelier – all carried on four square marble-faced piers. Directly beneath the dome the outline of the circle is repeated in the panel of the geometric floor tiling. The short bar counter is set to one side of the rotunda with recessed back bar panel behind, while the walls are faced, framed and edged with decorated stone tiles that curve around the door and window openings.

6. Madigan's, No. 25 North Earl Street

North Earl Street was one of the streets that experienced considerable destruction during the bombing of the General Post Office by HMS *Helga* during the Easter Rising in 1916. Between 1917 and 1919 No. 25 was rebuilt and Madigan's pub was laid out at ground level to the design of the architect Laurence McDonnell. Later, in around 1990, the original pub front was replaced by a plain framed and tiled opening with gold-coloured trims, a central door and two side windows, and an elaborate decorated cornice. A few doors along the street is a full-sized bronze figure of the writer James Joyce created by Marjorie Fitzgibbon in 1990.

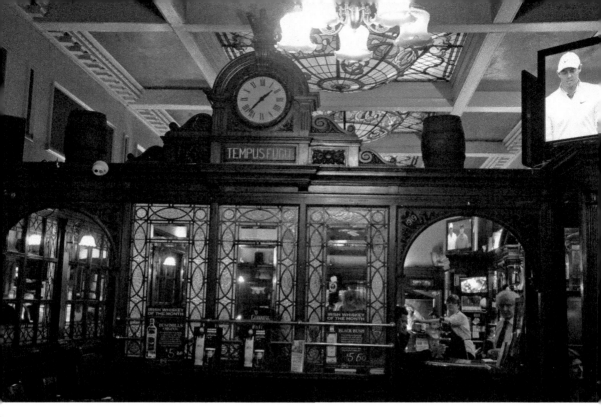

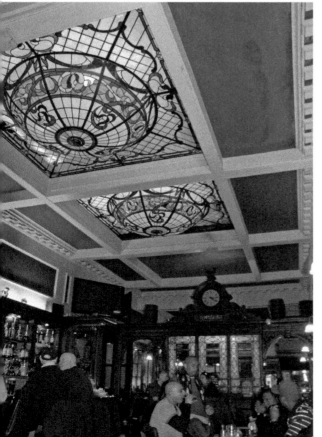

Above: The framed and glazed room divider, with arched openings and clock in Madigan's.

Left: The interior of Madigan's pub with the delicate stained-glass ceiling panels created by the notable stained-glass artist Harry Clarke.

The internal layout has a long, narrow attractively designed space – a stunning exercise in Victorian imagery – divided into a front and rear section. The floor has a geometric pattern of small coloured clay tiles all the way through. The polished bar counter has a marble top that stretches along one side, behind which the back bar panel is set into a Georgian-style crafted cabinet with pedimented panels. On the far wall is a continuous panel of mirrored tiles and frosted glass panes set into dark polished glazing bars in imitation of windows. The two sections of the pub are separated by a wooden screen with decorated glass panels set between a pair of archways and crowned by a large circular clock. A small wooden-framed office was incorporated into one side of the screen. The most significant element of the interior is the ceiling. This is divided into large panels by beams and cross-beams. Four of these are filled with stained-glass panels by the noted stained-glass artist Harry Clarke. These have drop-down half-spheres with delicate stained glasswork.

7. O'Connell's Bar, No. 30 Batchelor's Walk

O'Connell's Bar is a recently established pub that dates from around 1980 and was initially named Carr and O'Connell's. The ground-level pub is set into the three-storey Liffey-side terraced house, which previously held a bicycle shop. The standard Victorian-style pub front has the usual uprights, doors, display window and fascia. This, however, is as far as the Victorian ideal goes, as internally the pub is decidedly twentieth century in style with a remarkable vaulted double-height gallery. The initial entrance area of the pub has a trim wooden bar counter, glazed panelling, mirrors, and a framed and moulded plastered ceiling. At the far end of the short space a wide segmental arch leads to the highly imaginably conceived gallery. This is, in effect, a long tunnel divided into an upper and lower level. The upper level starts as a narrow metal deck that widens out as it stretches back from the entrance area to provide seating areas, with metal side rails that allow patrons view the lower level below. Overhead is a dramatic brick semicircular groin vault, which springs from the lower-level brick wall underneath. Here the lower-level bar extends beneath the line of the metal deck, with illuminated back bar and builtin seating against the side wall. The entire space on both levels is attractively illuminated by banks of coloured lighting.

8. The Oval, No. 78 Middle Abbey Street

The Oval was established in 1822 by James Cooney. James was followed by a succession of owners including Daniel Shelly and Bernard Dunne. Peter and Bridget Coyle took over in 1848 when the ticket office for the Royal Mail coach that served the west of Ireland was based next door. Peter was a coach builder and while he worked

The initial entrance of O'Connell's Bar has a standard bar counter, panelled ceiling and an arched entrance to the vaulted gallery beyond.

The double-height gallery section of O'Connell's stretches backwards under a dramatic brick vault.

on the servicing of the coaches, Bridget looked after the pub. John Egan took over the premises in 1902 and completed an elaborate renovation of the pub. However, during the 1916 Easter Rising the building was damaged by shellfire from the HMS *Helga*, which had sailed up the Liffey. It was firing on the nearby General Post Office, the command centre of the Republican forces. A remarkable photograph taken shortly after the Easter Rising is displayed in the pub and shows the bombed-out building. The front wall remains intact but the roof and interior have been destroyed. The pub lay unused until 1922 when Egan had the building restored in a rich Victorian style. The architect was Laurence McDonnell and he retained the original street front and divided the interior into a sequence of bars on each floor, connected to one another by open stairs. The curved pub front at ground level has central display window and door, set between stone classical columns, flanked by side lights and end piers with a stone fascia overhead. The upper floors have a bow window on the first and second floor and a round-headed window on the third floor. An unusual architectural effect is the roof-level parapet. This has an open semicircular arch that acts as a visual link between the higher buildings on either side of the pub. Internally, each floor presents a rich application of Victorian styling, including ceramic floor tiling, inbuilt and freestanding seating, a polished hardwood bar counter, brass trimming, framed display cabinets, carved wooden counter dividers and plastered ceilings. Each floor has a separate bar

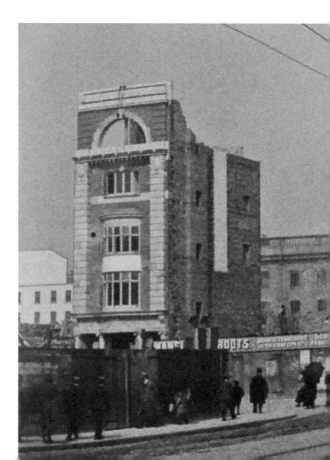

The remarkable 1917 photograph of The Oval shows the roof and interior of the building damaged by the bombing of the area during the Easter Rising.

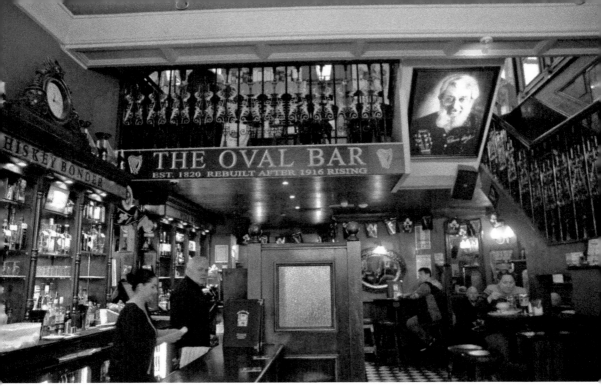

The interior of the multilevel Oval pub was rebuilt in a Victorian style by John Egan in 1922.

with wooden access stairs and elaborate metal railings that allows views from one floor to the other.

The Oval saw the setting up of the Irish Hospitals Sweepstake in the bar in 1930 by Joe McGrath, the bookmaker Richard Duggan and Captain Spencer Freeman. The 'sweep', as it was usually known, was a lottery and based on the winning horse in a number of races to provide finance for Irish hospital developments. It was the only legal sweepstake in the world at the time and attracted ticket purchasers from around the world, particularly America and Britain. Each winning ticket was assigned to a horse in a given race and the ticket that drew the winning horse received a substantial prize. The sweep ceased to operate in 1986 when the final draw was held.

9. Slattery's, No. 129 Capel Street

Slattery's pub was built in 1885 on the corner of Capel Street and Mary Street on the site of an earlier pub that was established in 1759. It is one of the few Dublin pubs where the licence arrangement allows for an early opening time of 7 a.m. and it is one of the few purpose-built public houses in the city. The three-storey rendered Victorian-style elevation on each street has a series of windows on each level – one above the other. These are positioned between bays of flat full-height columns, or pilasters. The rectangular ground-level windows are the largest, the first-floor windows are round headed and the top-floor windows are square, while each of the pilasters is decorated with a range of emblems, geometric panels and a continuous

The curved, rendered and decorated corner entrance to Slattery's pub.

decorated cornice in the place of the more usual pub fascia. The curved corner bay acts as the entrance where the ground-floor window is replaced by double doors. Internally, the floor is tiled in a coloured pattern of Victorian ceramic tiles that contrast with the dark polish of the double central bar counter. Both accentuated by the light from the large ground-floor windows. The bar has a back-to-back arrangement with a tall, framed and glazed back bar panel. Near the entrance is an elaborate staggered wooden stairs that leads to the first floor, where the layout is similar but with a less elaborate bar counter.

An unusual feature of the pub is the small ground-floor museum panel dedicated to the Easter Rebellion, called the '1916 Commemorative Wall'. This focuses on the main event of the rebellion that took place in the General Post Office, a short distance away on O'Connell Street. Here the Republican forces, the Volunteers and the Irish Citizen Army took over the General Post Office at the beginning of Easter week 1916,

The Victorian tiled floor, wooden central bar front and the 1916 Easter Rising Commemorative Wall of Slattery's pub.

which they regarded as the national centre of communications. The rebel force was headed by Patrick Pearse and James Connolly and the post office suffered a sustained attack by the British Army, assisted by heavy shelling from the HMS *Helga* that had sailed up the River Liffey. The naval bombardment, in particular, was devastating and the post office and many of the surrounding buildings were reduced to ruins. The insurgents held out for a week, but were finally forced to surrender, following which the leaders were executed by firing squad. The Commemorative Wall is on the ground floor of the pub and presents a rich display of Volunteer uniforms, weapons, medals, historic documents, photographs, and other items of 1916 memorabilia. Michael Collins, the leader of the Republican forces during the War of Independence was a frequent patron of Slattery's and the pub had a secret door that allowed Collins and others escape in the event of a raid by the British forces. Regrettably, the escape door no longer exists.

Temple Bar Neighbourhood

Temple Bar operates mainly as the city's entertainment hub with a range of public spaces, galleries, pubs, restaurants and theatrical amenities. The neighbourhood sits within the rectangular area enclosed by the River Liffey, Trinity College, Dame Street and Christchurch Cathedral. The neighbourhood dates partially from the medieval period and partly from the seventeenth-century development undertaken by Baron Temple, although the street architecture is mainly nineteenth century.

10. The Auld Dubliner, Nos 24–25 Temple Bar

The name 'The Auld Dubliner' is derived from the accentuated Dublin accent where the word 'old' is pronounced 'owled' – hence the name. The building is positioned at the junction of Temple Bar and Anglesea Street and fronts onto both streets. The three-storey Georgian house was built in the early 1800s. In 1840 Thomas Hunt ran a grocer and spirit merchant business from the premises, followed by Thomas Murphy in 1890. Today the plain rendered building has standard Georgian windows on the first and second floors and staggered quoins at the corner and ends. The pub front has a series of wide windows set between rendered piers with the name, The Auld Dubliner, mounted on the overhead fascia. The main entrance is set into a corner-angled porch and on one side is a large coloured advertising mural at street level. This depicts a portly, bearded seafaring man with his hands in the pockets of his naval greatcoat. Beside him is a dog raising its leg and relieving itself. In the background is an illustration of a stained-glass pub window that provides the name of the sailor: the Auld Dubliner.

Whatever original Victorian features existed inside the pub in the past have recently been removed and today the plain, but nevertheless vibrant, spacious bar on the ground- and first-floor levels has a range of typical pub elements. These include stone and wooden flooring, exposed brickwork, small alcoves shaped by low-level wooden partitions, wooden stairs linking the floors, sheeted walling and wooden bar. In addition, the display of pub memorabilia – including mirrors, photographs, sculpture, cart wheels, advertising signs, and stained glass windows and panels – adds to the overall atmosphere.

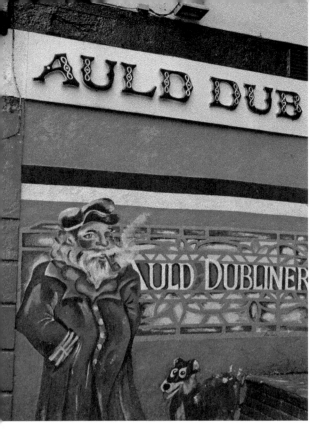

Left: Wall mural depicting the 'Auld Dubliner' figure on the gable wall of the pub of the same name.

Below: The plain but atmospheric interior of The Auld Dubliner pub is emphasised by the woodwork, stained glass and memorabilia.

11. The Bank, Nos 20–22 College Green

The Bank pub on College Green is immediately adjacent to Trinity College and former Irish Houses of Parliament on College Green. The premises were originally occupied by the British Mutual, who sold it to the Belfast Banking Company in 1892. The Belfast Banking Company employed W. H. Lynn as architect and embarked on an elaborate building project that was completed in 1894. In 1923 the building was sold to the Royal Bank of Ireland, who merged with the Provincial Bank of Ireland and the Munster and Leinster Bank to form the Allied Irish Bank (AIB) in 1966. Around 2000 the bank building became redundant and was refurbished as a bar and restaurant with a minim of interference with the 1892 design.

Lynn's building consists of a tall four-storey complex block of red sandstone with a turret at one corner. The ground level has horizontal masonry bands with a central scrolled and pedimented doorcase. Overhead, the two upper storeys have a giant temple front and elaborate cornice, above which is a low upper floor and a stubby dormer window. The slim corner turret stands five storeys high with a copper conical cap, giving the front a decidedly Scottish Baronial character that merges into the Victorian streetscape of College Green. Internally, the bar and restaurant fit into the former banking hall and offers a remarkable drinking and dining experience. This includes the central marble faced U-shaped bar counter arrangement and mosaic

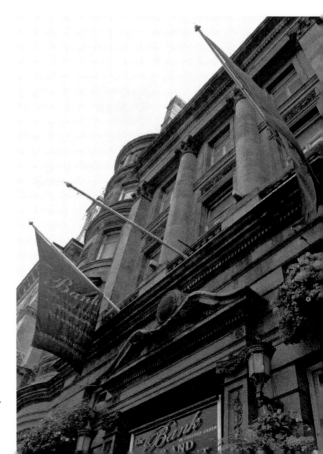

The Scottish red-sandstone front of The Bank bar merges into the Victorian streetscape of College Green.

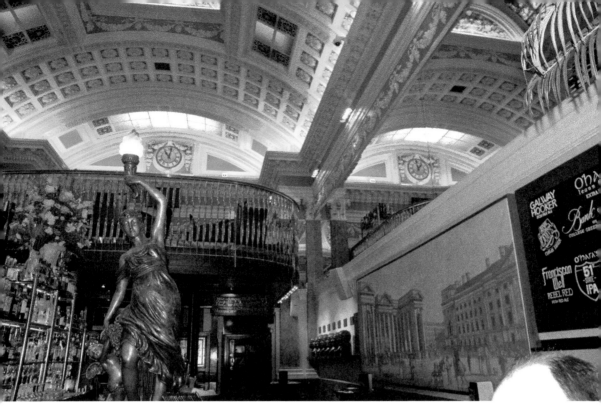

The interior of The Bank pub offers ornate plasterwork, polished red-sandstone pillars, an upper-level gallery and vaulted ceilings.

flooring and an upper-level gallery with views over the lower ground level. Around the edges of the space are an arrangement of tall polished red-sandstone Georgian pillars that support the ornate and plastered ceilings and a sequence of coffered segmental vaulting and a glazed barrel vault. The walls and ceilings are examples of handcrafted coloured plasterwork including arches, swags and panels, as well as figure sculpture and wall mounted views of eighteenth-century Dublin. Curiously, the large mirrors spaced around the upper level of the walls visually exaggerate the scale and complexity of the interior, particularly the vaulting.

12. Bowe's, No. 31 Fleet Street

No. 31 Fleet Street was built as a four-storey Georgian house in 1805, although the Victorian layout of the pub dates from 1854 when it was inserted into the ground floor of the house by Christopher McCabe, who operated a dairy. Further work was later completed by John O'Connor around 1880. James Rochford took over around 1895 and his name can still be seen on the mirrors inside the bar. In 1910 the pub came into the ownership of James Bowe, wine and spirit merchant, and he changed the name from Rochford's to Bowe's. Bowe's rendered Victorian-style front is narrow and one of the most elaborate and intricate in Dublin. It has a double display window with the door to one side. This includes four carved columns with a floral and bird carving on the top and an equally elaborate fascia. This has a moulded cornice, a patterned lintel

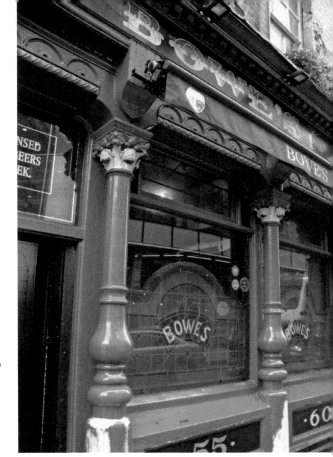

Right: Bowe's is an outstanding example of a rendered Victorian pub front design in the Dublin area.

Below: The iconic Victorian interior of Bowe's pub with dark mahogany woodwork, stained-glass, mirrors and a framed embossed ceiling.

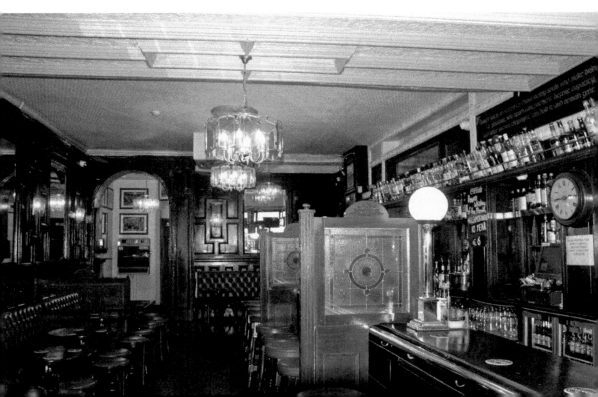

underneath and the gold-painted name against a black background. Higher up there is a large double-faced clock projecting from the face of the second storey with Roman numerals and the pub name. Immediately inside each of the windows is a stained-glass advertising panel featuring the pub's name.

The pub offers a rich 'old world' experience inside. On one side of the narrow space is the bar counter. This has a polished wooden top with moulded decorations on the front and a pair of white globe lamps mounted on brass stands. The counter is divided into individual sections by framed dividers with stained-glass inserts. These are a common feature of Dublin pubs and give a level of privacy to customers who wish to indulge in private conservations. Behind the bar counter is a notice that reads: 'Bowe's Bar is dedicated to those merry souls who make drinking a pleasure, who reach contentment before capacity, and what so ever they drink, can hold it and remain gentlemen.' On the far side of the pub is a bank of plush red-coloured seating, over which an arrangement of mahogany panelling and decorated mirrors stretch up to the framed and embossed ceiling. A recent addition to the pub is a snug positioned near the doorway. This is framed with both wooden panels to match the side walls wall and stained glasswork.

13. The Brazen Head, No. 20 Lower Bridge Street

The Brazen Head is adjacent to Father Matthew Bridge – one of the earliest of the city bridges to span the River Liffey. The current building dates from 1754 and replaced

The white rendered four-storey eighteenth-century Brazen Head pub is entered from an enclosed courtyard.

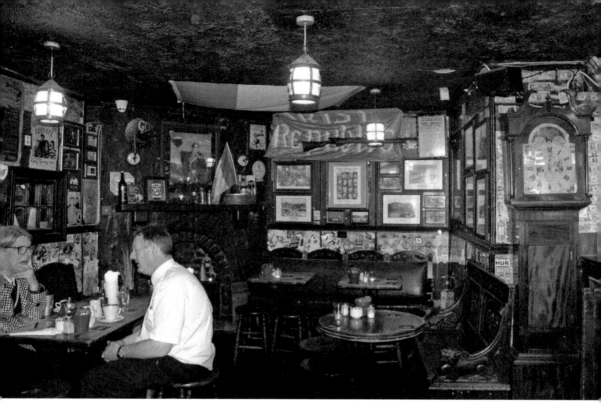

The interior of The Brazen Head has a sequence of interconnected rooms with low ceilings, overhead beams and the occasional fireplace.

an older seventeenth-century wooden structure, although there is a tradition that the pub's origins date from a twelfth-century coaching inn on the same site. James Joyce refers to the pub in *Ulysses* when one of the characters in the book remarks, 'You get a decent enough do [a meal] at the Brazen Head for a bob [a shilling].' The name of the pub is a common one that is based on the medieval tradition of a mechanical head, said to have been owned by Roger Bacon.

Today the pub is accessed from an enclosed cobbled courtyard reached from Bridge Street through a recently built antique-styled archway. The white rendered four-storey house front has a pattern of Georgian windows on the upper floor, three of which are round headed, with an off-centre doorway and side windows at ground level. The entrance courtyard acts as a beer garden and is partially covered with a striped awning, and a life-sized military figure in full armour. The spirit of the eighteenth-century building survives inside The Brazen Head. This includes a sequence of interconnected rooms with low ceilings, overhead beams, the occasional fireplace and red-coloured plastered walls. These are covered with images, posters, photographs, price lists, foreign currency notes, badges, mirrors, and similar mounted memorabilia, with the short wooden bar slotted into a corner. Patrons of The Brazen Head are said to have included Robert Emmet, Jonathan Swift, Wolfe Tone and Daniel O'Connell – Emmet being politically the most famous. The nationalist leader had an office in The Brazen Head from where he planned the 1803 Rebellion. The rebellion failed and Emmet was

arrested, tried and found guilty of treason. He was subsequently hanged and beheaded at the junction of Thomas Street and Bridge Street, close by his Brazen Head office.

14. The Lord Edward, No. 23 Christchurch Place

The Lord Edward pub is in a corner position at the junction of St Werburgh Street and Christ Church Place, opposite Christ Church Cathedral. The pub is named after the Irish nationalist Lord Edward Fitzgerald, son of the Duke of Leinster. Lord Edward served in the British Army during the American War of Independence where he was wounded. He returned to Ireland and became involved in the failed United Irishmen Rebellion. He was wounded while being arrested on the charge of treason and died from his wounds in 1798. He was buried in St Werburgh's Church in St Werburgh Street, diagonally across the road from The Lord Edward pub. The Lord Edward pub was opened by Thomas Cunniam in 1901, in a house originally built in 1875. The pub, then called the Cunniam Tavern, was inserted into the ground- and first-floor levels of the three-storey red-brick house, which still retains most of its Victorian character. In 1967 a restaurant was opened on the second floor and the name of the premises was changed to The Lord Edward. The premises were sold to the Lyster family in 1967 and the restaurant ceased to operate in 2015.

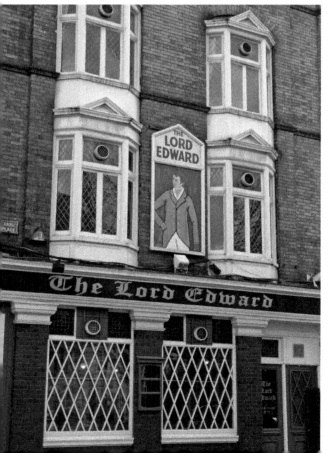

The first-floor-level portrait of Lord Edward Fitzgerald dominates the Christchurch Place elevation of The Lord Edward pub.

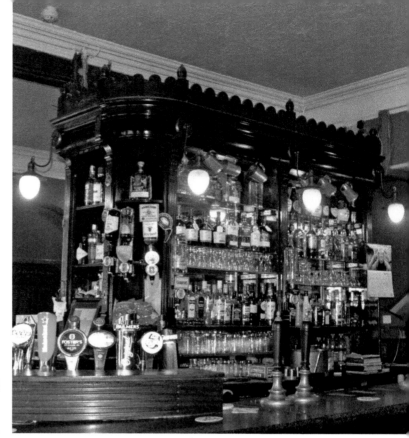

The marble-topped bar counter, traditional pump handles and the elaborate back bar of The Lord Edward pub.

The three-storey front on both faces has large shop windows on the ground level with diamond-shaped panes, set between brick piers. Overhead the decorated fascia inscribed with The Lord Edward name stretches around the corner. Today the upper part of the house retains much of the character of a Victorian house. This includes red-brick walling with first- and second-floor projecting bay windows on the Christ Church Place front. A prominent feature of the same elevation is the large coloured portrait of Lord Edward between the first-floor bay windows. The ground-floor area is small with a curved central U-shaped bar counter. This has framed wooden sides, a marble top and decorated back bar. The pub walling is decorated with framed historic images relating to Lord Edward as well as panels of stained glass. The pub once had a number of snugs but today only one remains operative – in one corner of the bar – although the serving hatch of one of the other snug survives in the wall adjacent to the bar counter. The upstairs bar has inbuilt seating, exposed wooden beams, stained glass, arched wall panelling, a fireplace and a corner bar counter.

15. Merchant's Arch, No. 48 Wellington Quay

The Merchant's Arch, formally called the Merchant's Hall, originated as the Merchant's Guild Hall. The site was given to the Merchant's Guild for their new hall by the Wide Streets Commissioners and is at a point where the pedestrian Halfpenny Bridge crossed the River Liffey. A condition of the grant was that a public way would be provided

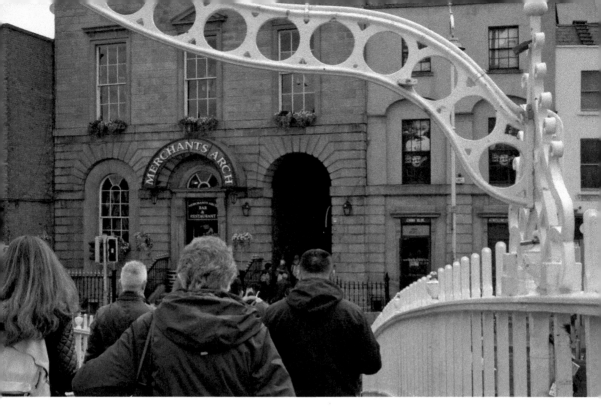

The Halfpenny Bridge crosses the River Liffey and leads to the Merchant's Arch pub.

to link the bridge with Temple Bar. Frederick Farley was appointed architect and work began on the hall in 1821. Darley's design consisted of a formal Georgian-style double-storey granite building that faced across the river. This had three arches on the ground level. One was open and provided the right of way to Temple Bar. The centre arch had a rectangular door with a semicircular fanlight and was reached by stone steps and a metal handrail. The third arch incorporated a round-headed Georgian window, while overhead the upper floor had three vertical Georgian windows. In 1841 the guild was disbanded and the building was sold, following which it underwent a number of different uses such as a school and a factory. In 1993 the building changed hands once more and was converted to a bar and restaurant. In the successful reuse of a significant historic building, Darley's elegant palazzo elevation was retained, except for the addition of a raised semicircular sign over the door that read 'Merchants Arch'.

Internally, the walling of the ground level of the pub is framed by a system of high-level moulded arches, with the wooden-framed counter, elaborate back bar and large advertising mirror. A high-level gallery at the rear is separated from the main bar by similar arches, from where patrons on the gallery level can oversee the bar and the far bank of the River Liffey through the front windows of the building. An unusual and almost hidden feature is the dramatic elegant stone stairway that links the ground and upper floors of the pub. Here a range of framed images are mounted on the wall of the oval-shaped stairwell and seem to lead the visitor upwards. The second floor of the pub follows the ground-floor arrangement with a front bar and a raised gallery to the

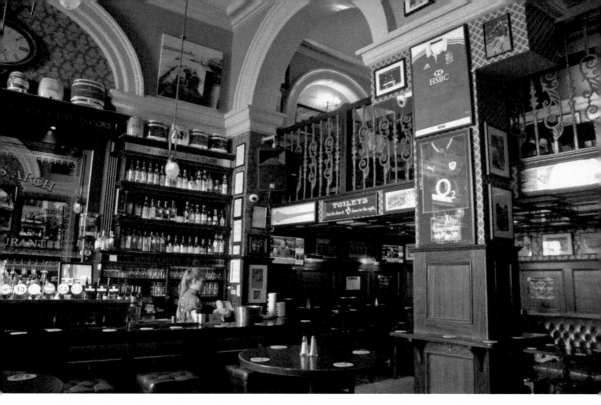

The bar, back bar, arches and upper-floor gallery of the Merchant's Arch pub.

rear. The gallery is reached by stairs and decorated metal railings that returns across the front of the gallery and offers views across the river. Surprisingly, a light aircraft hangs from the exposed structural roof timbers.

16. The Norseman, No. 28 Essex Street East

The Norseman pub stands at the corner of Essex Street East and Eustace Street and dates from around 1696 when it went under the name of the 'Wooden Man Tavern' after a large wooden Viking figure that once stood nearby. During the eighteenth century it was called the Royal Garter and in the following century it was operated by a number of publicans, including Peter Kavanagh and James Monks. The present-day pub and building dates from 1900 and was named Farrington's after a character from James Joyce's *Dubliners*. The use of the current name, 'The Norseman', dates from 2014 and was prompted by a 1970s archaeological discovery of the remains of a Viking longship in the nearby Wood Quay area. In 1992 a stone-lined medieval well was discovered in the street outside the Eustace Street side of the pub. This was converted to a historic street element by being opened up and enclosed by a low stone enclosure wall in the footpath.

Today the three-storey corner building faces onto Essex Street and Eustace Street, with the recently installed Victorian-style timber ground-level pub front extending around the corner. This has wide display windows set between decorated framed uprights, a corner entrance door and a continuous fascia. Overhead, the rendered

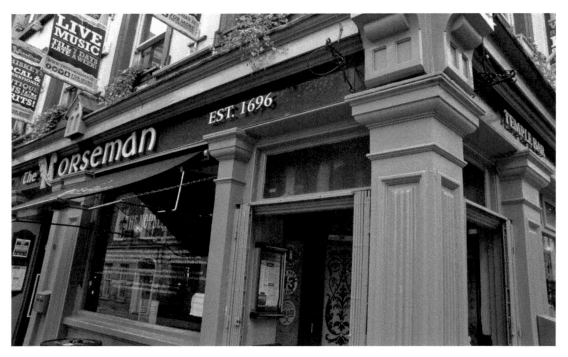

The recently installed timber Victorian pub front of The Norseman.

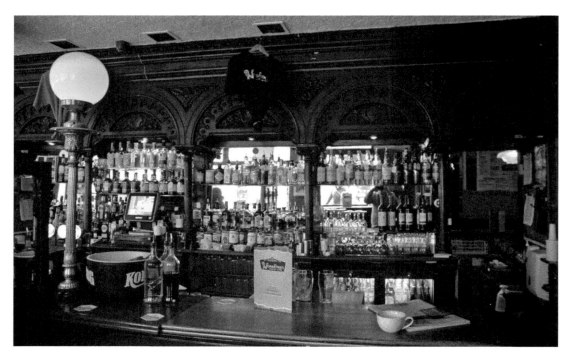

The handcrafted wooden bar counter and elaborate back bar of The Norseman pub.

upper floors have a system of Georgian proportioned windows on both levels. Inside, the wooden-framed bar counter stretches along one side of the pub, with cast-iron columns and mounted light globes. The counter front is divided into individual sections by carved wooden bar dividers, with framed panels, round-headed mirrors and curved tops. Behind the counter, the back bar is framed with elaborate joinery work including slim columns, richly carved arches and background mirrors. Elsewhere, the bar has a fireplace and wall-mounted artwork. Upstairs, the first-floor bar has a twentieth-century character with a wooden bar front, polished wooden floor, and plain plastered walls and a flat ceiling.

17. The Oliver St John Gogarty, Anglesea Street/Fleet Street

The Oliver St John Gogarty is positioned on the corner of Anglesey Street and Fleet Street in the Temple Bar area. The present owner took over the pub in 1992 and began a programme of refurbishment that included the incorporation of a lavish nineteenth-century interior of exposed beams, Victorian furniture and memorabilia, as well as artworks and wall murals.

The refurbishment also includes streetscape elements such as bay windows and flags. During the same period the name of the pub was changed from the Anna Livia to the Oliver St John Gogarty – a reference to the notable Dublin surgeon, writer, poet, politian, athlete and football player who once played for Preston North End. The flamboyant fictional character of Buck Mulligan in James Joyce's novel *Ulysses* is said to be modelled on Gogarty. This connection is emphasised by the incorporation of a wall mural depicting Gogarty into the design of the pub front and a full-sized

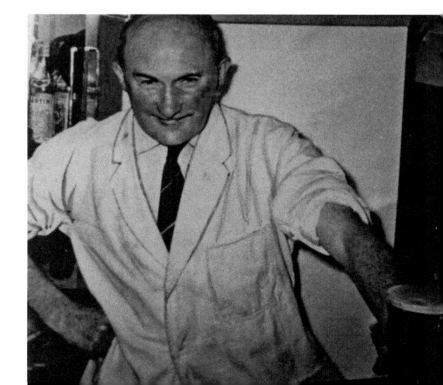

John Keane, father of the present owner of The Oliver St John Gogarty, in a traditional barman's white jacket, shirt and apron, serving a pint of Guinness.

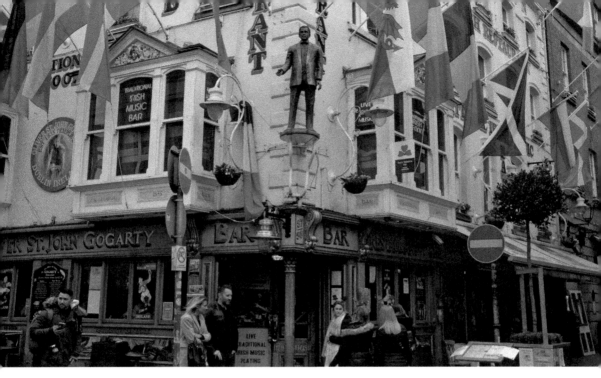

The brightly decorated front of The Oliver St John Gogarty, with the first-floor bronze image of Gogarty, marks the corner of Fleet Street and Anglesey Street.

bronze image of Gogarty facing onto the street at first-floor level. Today the brightly coloured and flag-bedecked exterior is a prominent feature of the Temple Bar corner, while internally the ground floor holds the bar, the first floor the Live Music Centre and the second floor the restaurant.

During the 1930s the pub, then called O'Neill's of Fleet Street, was owned by Michael O'Neill who operated as a wholesale, retail wine and spirit merchant. At this period Guinness and the whiskey distillers delivered the beverages to the pubs in barrels. These were delivered to the pub cellars where the liquor was bottled and labelled by the individual pubs. O'Neill also operated another pub nearby called O'Neill's of Suffolk Street, where John Keane, father of the present owner of The Oliver St John Gogarty, worked as a barman. One of his duties was to collect freshly bottled whiskey from the Fleet Street cellar and delivering it up to the Suffolk Street Pub. In later life John liked to tell how, dressed in his white uniform, he carried the baskets of bottled whiskey through the streets between the two pubs. The Keane family also have a photograph of John, taken shortly after and serving a pint of Guinness, in his traditional white uniform of jacket, shirt and apron. The family also retain a letter from Michael O'Neill, dated December 1934, inviting John to call on him to discuss his appointment as a barman.

18. The Old Storehouse, No. 3 Crown Alley

The Old Storehouse is a recently established pub in what was originally part of a three-storey mid-nineteenth-century warehouse that still retains its brown-brick structure, elliptical granite carriage arches, cut-granite surrounds, multistorey vertically

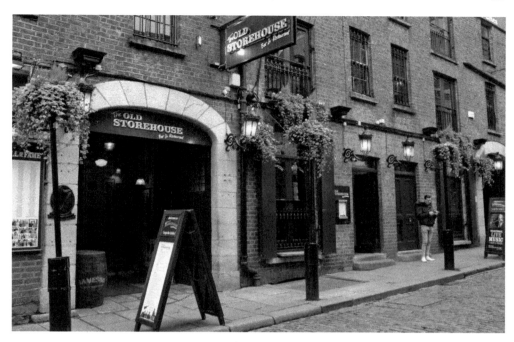

The original brick walling and stone coach arches of The Old Storehouse pub has largely been retained.

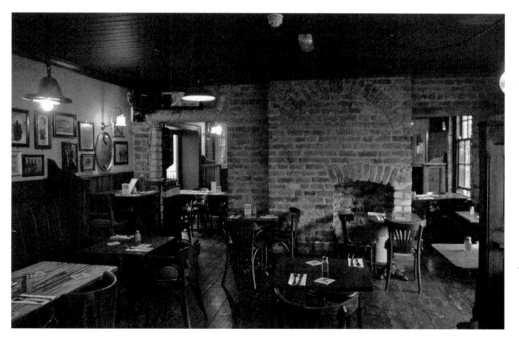

The wooden flooring, exposed brickwork and wooden ceiling of The Old Storehouse highlight the character of the former warehouse.

arranged loading bays, timber-shuttered loading bay, and original 'Oman and Sons' sign at roof level. The entrance to the pub is through one of the coach arches with the pub name inserted directly underneath the crown of the arch. The interior of the pub is laid out in a series of bars at different levels with interconnecting wooden stairs. Like the exterior, the interior character of the warehouse has been largely retained and enhanced through the use original wooden flooring, exposed brickwork, timber wall sheeting, wooden ceilings and timber beams. The bar counter is panelled in wood with the back bar arranged into small boxlike cubicles. Also displayed around the walls are old advertising signs and antique fittings.

19. Palace Bar, No. 21 Fleet Street

Palace Bar is one of the most elaborate and celebrated of Dublin's Victorian pubs and was established by the Hall family around 1823. In 1840 John Stanford operated as a grocer, tea, wine and spirit merchant, although the current layout of the pub dates from around 1890. During the War of Independence, between 1919and 1921, the Republican leader Michael Collins frequently held meetings in the snug. Later, in 1946, the pub was bought by Bill Aherne and today the pub remains in the ownership of the same family. One of the pubs most famous patrons during the 1940s and 1950s was Bertie Smyllie. He was the editor of the *Irish Times*, whose offices were nearby, and he held court in the pub each day from 5 o'clock onwards, where he hosted and briefed the city's newspapermen. Another patron from the *Irish Times* was John Crozier, who

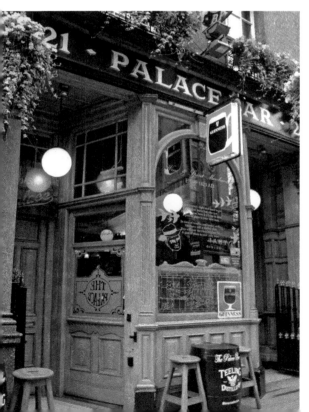

The tall, narrow, stepped and arched timber pub front of the Palace Bar is set between polished stone uprights.

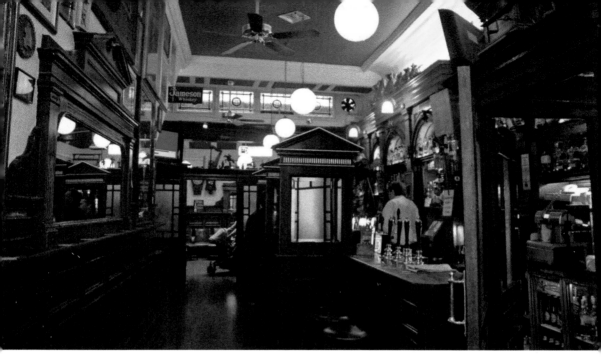

The interior of the Palace Bar features a handsome display of polished hand-carved joinery, including bar counter, back bar, bar dividers and wall panelling as well as mirrors, stained glass and a dramatic roof lantern.

was responsible for creating and running the 'Crossaire' cryptic crossword from the pub. Other notable patrons included the writers Patrick Kavanagh, Seamus Heany, Flann O'Brien, and Brinsley McNamara. O'Brien produced a twice-weekly column for the *Irish Times* and Kavanagh described the pub as 'the most wonderful temple of art'.

The narrow Victorian pub front of Palace Bar consists of a pair of polished ornate stone uprights, above which is the wooden facia with the name sign extending across the full width of the building. Lower down between the uprights a pair of timber recessed doors, flank the tall central display window with its elegant arched design. Immediately in front of the entrance is a range of brass commemorative plaques arranged around a lamppost and set into the footpath. Inside the doors the front section of the pub has a long narrow interior that widens out into a square room at the rear. Adjoining the doorway is the snug with polished framing and glazing. On one side of the narrow front section is the wooden bar counter divided into intimate spaces by carved dividers, each decorated with a pediment and a mirror. Behind the counter is the highly elaborate back bar arrangement of carved wooden frames, arches and mirrors. The wall opposite the bar counter has wooden panelling and old advertising signs. A framed and glazed screen with stained-glass panels separates the narrow front and rear sections. Beyond this, the rear section has a dramatic coved ceiling with a large central stained glass lantern. Here the walling is panelled, above which are hung pictures of Dublin literary notables. The pub has recently opened a purposely designed Whiskey Palace on the upper floor. This carries a large stock of whiskey including its own brand, titled the 'Fourth Estate' with an image of Bertie Smyllie on the label.

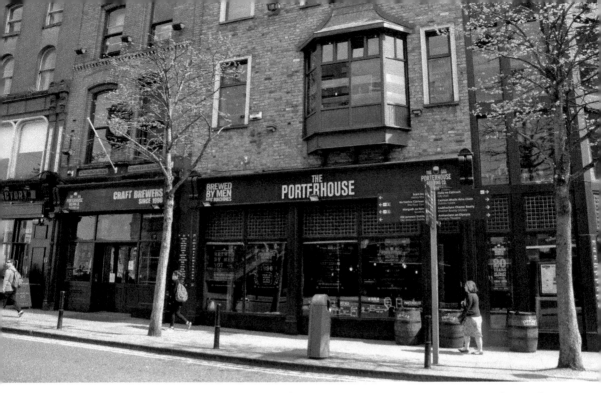

The Porterhouse pub extends along Parliament Street, incorporating an earlier pub front and an extensive new building.

20. The Porterhouse, Nos 16–18 Parliament Street

The origins of The Porterhouse pub lie in a terrace of four-storey houses in Parliament Street, adjacent to Grattan Bridge. The pub was opened in the ground floor of the narrow house around 1880, although the present pub front has only been recently inserted. This has a characteristic Victorian-style design with a central double door flanked by rectangular side windows and an overhead fascia. During the 1990s a number of the houses were removed and the pub was extended along the street as far as the junction of Parliament Street and Essex Street East. The new building matched the height of the original pub and was given a pub front that matched that of the original pub in scale and style. This included the matching fascia with plain rectangular display windows beneath. This design, however, changes at the street corner. Here the brickwork was replaced with an exposed concrete frame with a splay at the corner. The square windows were set into the frames on the upper levels with the plain entrance door at the ground-level splay, with a simple sign.

The internal layout of the original section of the pub remains in place and retains a few of the original features such as the wooden ceiling panels and the wall panelling. Newer elements include the wooden bar counter, framed back bar panels, wall images and exposed service ducts. The new section of the pub, which opens off the older section, is made up of a sequence of interlinked bars laid out with a decidedly modern flavour including changing floor levels, brightly tiled surfaces, individual wooden bar counters, framed display cases, exposed service ducts, high-level beams and polished

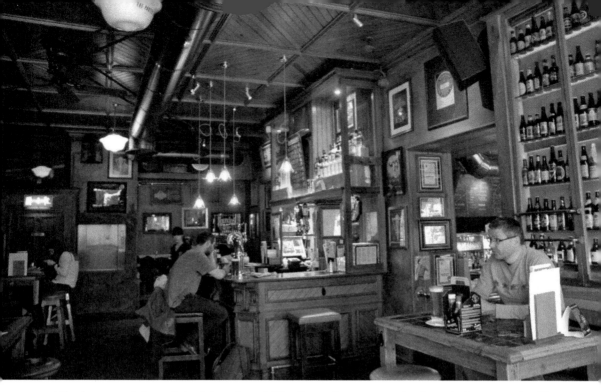

The layout of the original interior of The Porterhouse remains largely intact and still functions as part of the overall pub.

copper work. The Porterhouse was the first pub in Dublin to produce its own craft beer and it opened for business in 1996.

21. The Stag's Head, No. 1 Dame Court

The Stag's Head is located on the corner of Dame Court and Dame Lane and reached from Dame Street through a narrow covered passageway, where a splendid example of a Dublin Victorian pub can be found. The pub was established around 1770 and in 1830 went under the name of 'John Bull's Hotel and Tavern'. George Tyson acquired the premises in 1890 and five years later the building was rebuilt on the narrow site to the design of the architect Alfred McGloughlin around the theme of a stag's head, a common heraldic symbol of the time. Curiously, the pub across the street was originally known as the 'Stags Tail'. McGloughlin's design still survives intact today and the narrow Dame Court pub front is highly elaborate, with a central doorway and side window set between polished-stone pillars that support the overhead highly decorated stone fascia and name. High up on the corner of the building the large projecting double-faced clock carries the name of the early owner and developer: Tyson.

Internally McGloughlin's Victorian design survives intact. This includes wall-mounted stags' heads, a magnificent display of mahogany joinery work including carved arched wall panelling, a long panelled mahogany counter with a polished stone top, and carved glazed bar counter dividers. Elsewhere there are bevelled mirrors, stained-glass windows and panels – all set beneath framed wooden ceilings. An unusual

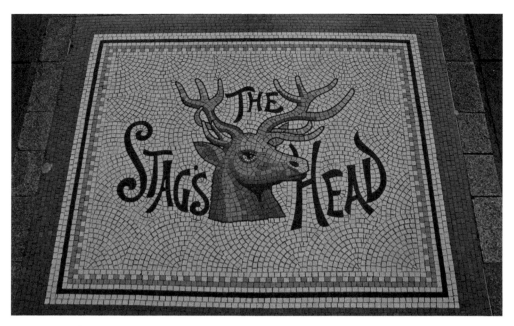

A mosaic advertising sign embedded in the footpath on Dame Street points the way to The Stag's Head pub through a narrow covered passageway.

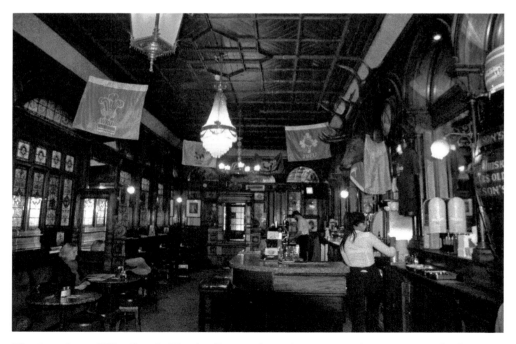

The interior of The Stag's Head offers a charming range of Victorian pub elements including the framed bar counter with a polished-stone top, arched back bar, carved bar counter dividers and stained-glass windows.

feature of the pub is the large snug at the rear of the bar. The walls are finished with wooden panels and mirrors, while overhead is a large roof light with stained-glass panels and a lantern. Another unusual feature associated with the pub, but not in it, is the mosaic advertising sign set in the footpath on nearby Dame Street. This has an image of a stag's head and points the way to The Stag's Head pub through a narrow covered passageway that leads to Dame Court. In recent years The Stag's Head has appeared in the film *Educating Rita* that starred Michael Caine and Julie Walters.

22. The Temple Bar, Nos 47–48 Temple Bar

Confusingly, The Temple Bar pub is in a street called Temple Bar and in the neighbourhood of Temple Bar. The history of the site goes back to 1599 when Sir William Temple, father of Sir John Temple, laid out his house and gardens here. In 1656 Sir John created the Temple Bar area by constructing a wall, or barr, to hold back the waters of the River Liffey and help reclaim the land. According to the date on the gable wall of the building, the development of the pub dates from 1840, when J. Farley operated as a grocer, tea, wine and spirit merchant. Fifty years later the business had come into the hands of P. Ramsbottom. The pub developed in two stages: an original small single room pub that has recently been expanded considerably by taking over the immediately adjoining buildings.

The original section of the pub straddles the corner of Temple Bar (street) and Temple Lane South, with pub fronts facing onto both streets. The part-timber, part-rendered

The extended Victorian timber pub front of The Temple Bar pub wraps around the corner of Temple Bar (street) and Temple Lane South.

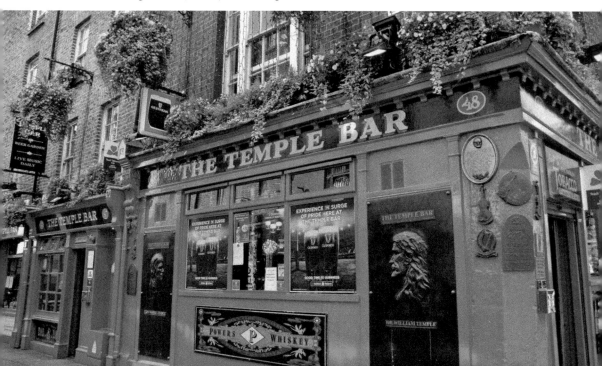

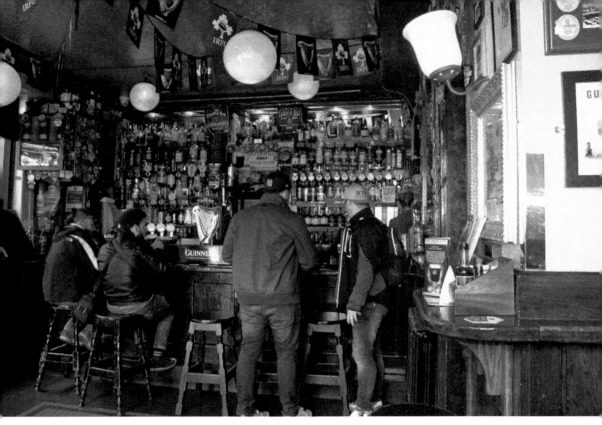

The original plain, framed bar counter of The Temple Bar pub with the well-stocked back bar behind.

pub fronts include timber uprights that support the continuous moulded fascia and painted name sign. Between the uprights is a mixture of display windows, historic plaques and advertising signs. In addition the corner has a slight chamfer, beneath which a low stone wheel-guard remains in place. This protected the pub walls from damage from passing cart wheels in times past. When the pub was expanded extra fronts were added and although they are a close match to the original they differ in height. The small original bar area has all the original characteristic of a typical Dublin Victorian pub. These include a plain framed counter with the back bar display behind, embossed ceiling, mirrors, and wall-mounted antique advertising signs. Although the original bar is small it provides inviting views of the sequence of newer bars that lead from one to the other, all following the Victorian ideals of the original section, with dark wood, framed counters and optics, glazed and panelled dividers, tiled flooring and old advertising signs. Additionally, the new section features a life-sized bronze statue of James Joyce and an enclosed beer garden.

23. The Turk's Head, No. 27 Parliament Street
The Turk's Head is positioned on a corner site at the junction of Parliament Street and Essex Gate. The name is a common one for taverns in Britain and is based on the heraldic image introduced from the crusades. The Dublin Turk's Head was established

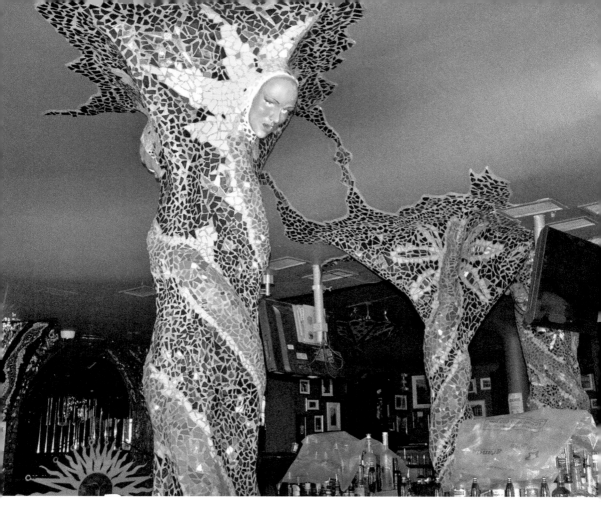

The extravagant, vibrant, colourful and recently created interior of The Turk's Head.

in 1760 as The Turk's Head and Chop House, although the present building was rebuilt around 1860 and the name was changed to the City Hall Tavern. Today the 1860s brick building is four storeys high, with the pub front at ground level. The Victorian-style timber front wraps around the corner and is of recent date. This has a sequence of three-pane display windows set between decorated uprights, a continuous fascia and a recessed canted corner entrance door.

The pub interior is a complete surprise and offers a vibrant twentieth-century design that presents a local interpretation of a 'Barcelona' styles over three floors. The ground floor has a mixture of wood and tiled floors, irregular wall panels of mosaics and mirrors, a range of spangled-shaped structural pillars with abstract mosaic designs, a central abstract mosaic bar counter, a full-scale bronze dancing figure and other abstract sculptural elements. The upper floors have similar imagery including the highly ornate metal stairs, concrete pillars, changing levels, abstract metalwork, bulbous shapes, colourful mosaic flooring patterns, vaulted ceilings, and a semi-abstract painted dome.

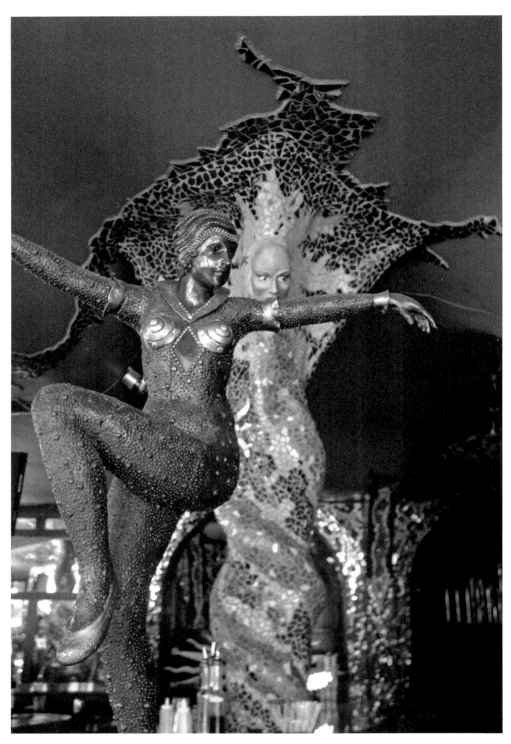

The unique full-scale bronze dancing figure and other abstract sculptural elements of The Turk's Head pub.

3

South Inner City Neighbourhood

The South Inner City Neighbourhood extends between Temple Bar on the north side and the Grand Canal on the south. This is the primary commercial and retail area of the south city. Historically, the laying out of the street network dates from the eighteenth century and includes Grafton Street, Baggot Street and the Great Georges-Camden Street axis, although much of the fabric dates from the nineteenth century with twentieth-century additions.

24. The Bailey, Nos 1–4 Duke Street

Situated in the terraced streetscape of Duke Street, The Bailey dates from around 1843 and was at one time named the Maltings. The pub came under the ownership of writer and artist John Ryan around 1957, prior to which the pub had a literary reputation and was frequented by international patrons that included Evelyn Waugh and John Betjeman. Ryan encouraged this reputation and during the 1950s the pub attracted writers such as Patrick Kavanagh, Samuel Beckett, Brendan Behan, Brian O'Nolan, J. P. Dunleavy, Padraic Colum, as well as writer-politicians Thomas Kettle and Arthur Griffith.

Situated on Duke Street, The Bailey has, over a number of years, been extended across the ground level of four buildings with a continuous shopfront. This has a series of timber windows and doors set between uprights with a continuous fascia and sign. Overhead the upper parts of the buildings are part of the Marks & Spencer store. One famous but now vanished feature was the statue of Captain Cuttle. He stood above the pub fascia dressed in his naval coat, white trousers and tricorn hat and with a sextant in his hand. The statue originally came from premises of Richard Spears, mathematical instrument maker of Caple Street, before ending up between the pair of oriel windows over The Bailey's fascia. The pub now has a partially open patio with the seating and tables extending along the street front. Internally The Bailey has a decidedly modern interior: a bright spacious gallery with plain subdued-coloured walls and joinery, chrome finishes, sharp edges, mirrors, backlit optics, plain tables, leather seating, big bar stools and deep sofas, all overlooked by a large portrait of James Joyce.

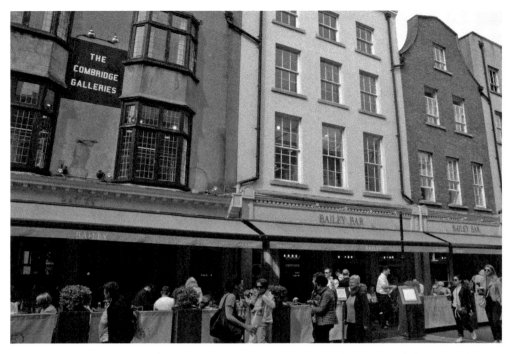

The extended pub front of The Bailey, with the irregular elevations of the upper levels.

The brightly coloured twentieth-century-style interior of The Bailey pub, with the prominent image of James Joyce.

On 16 June 1954 the first celebration of Bloomsday began at The Bailey, to mark the 50th anniversary of date depicted in James Joyce's novel *Ulysses*. Ryan, together with Flann O'Brien, Patrick Kavanagh and a few other literary figures, took part on a trip that traced the route of the journey across Dublin undertaken by Leopold Bloom, a character in the novel. The group travelled in a pair of horse-drawn carriages, with the occupants reciting excerpts from the novel as they drove along. The trip only achieved half of the intended route and ended with the group back in The Bailey. Nowadays, Bloomsday, named after Leopold Bloom, is celebrated every 16 June by enthusiastic Joyce fans.

25. The Bleeding Horse, Nos 24–25 Camden Street Upper

The Bleeding Horse is a wedge-shaped building originally at the apex of Camden Street and Charlotte Street. The establishment of the pub dates from 1649, although the current building was erected in 1871 to the design of the noted Victorian architect Robert Sterling. The pub has had several owners since then including the Ryan family in 1910 and the Morris family in the 1960s. The pub was renamed the Falcon during the Morris ownership, but was changed back to The Bleeding Horse ten years later, following which the interior was refurbished in 1992. At this time part of the interior

The spacious interior of The Bleeding Horse with the wooden supports extending upwards to the underside of the overhead galleries.

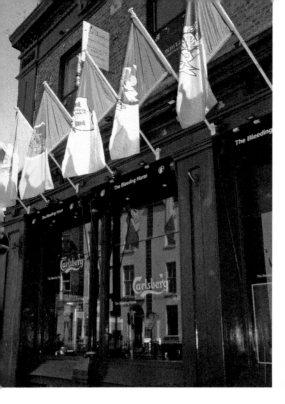

The Bleeding Horse side elevation faces onto Camden Street.

was changed from a double- to a single-storey arrangement. The central section of the first floor was removed to create an attractive spacious interior, although the edges of the first floor were partially retained in the form of high-level galleries with ornamental wooden balustrades. A circular-arranged bar fitted into the enlarged space at ground level with wooden ornamental panels and wooden posts that extend upwards to support the galleries.

The wedge-shaped front and side elevation face Camden Street. Here the large plate-glass windows at ground level are set between rendered and cast-iron columns, while the decorated fascia has projecting brackets along the face. Overhead, the brick first-floor level has a sequence of tall windows and a moulded parapet. Over the doorway on the wedge-shaped front is a large painting of a bleeding horse's head and neck with the date '1649' underneath. Outside the entrance is a stone set into the footpath that reads: 'Two horsemen rode to the Bleeding Horse' and refers to the story *The Cook and the Anchor*, published in 1845 by the celebrated ghost story writer Sheridan la Fanu. The story also mentions a sign over the inn door representing a white horse 'out of whose neck spouted a crimson cascade' with the information that 'this was the old Bleeding Horse'. The pub also features in the James Joyce novel *Ulysses*, where Leopold Bloom notes, 'I saw him in the Bleeding Horse a few times with Boylan the Billsticker.' Two storeys offer an account of how the pub acquired its curious name. One suggests that a horse expired in the yard after having been carelessly bled by a farrier while being treated for the tremors. The second tale recounts how a war-wounded horse fled from the nearby 1649 Battle of Rathmines, wandered into the pub and bled to death.

26. Bruxelles Bar, Nos 7–8 Harry Street

The Bruxelles Bar on the corner of Harry Street and Chatham Lane was built by James Mooney in 1886 on a site that combined house Nos 7 and 8. This was a period of considerable interest in spirituality, astrology and other supernatural ideas that inspired the architect J. J. O'Callaghan in his design for the building. The pub was initially called the Grafton Mooney and remained in the ownership of the Mooney family until 1973 when it was taken over by the Egan family. This period in history coincided with Ireland's entry to the European Union, or the Common Market as it was then known, and to mark this event the pub was renamed the Bruxelles – the capital of Belgium and headquarters of the Common Market. In another gesture to European harmony, the flags of the members of the Common Market were hung over the bar. O'Callaghan's design for the building was exuberant – a three-storey red-brick front with stone dressing. An unusual feature is the exuberant round stair corner turret at the Chatham Lane end of the building. The line of the winding steps is expressed externally with stone risers and the top is capped with a tall conical roof. The string of ground-floor pub windows are also unique with pointed church-like top sections. Recently, a partially open outside patio has been established along the pavement in front of the building.

The pub's interior is equally rich. The large saloon with its extended bar counter fills most of the ground floor, behind which the back bar display is framed in rounded

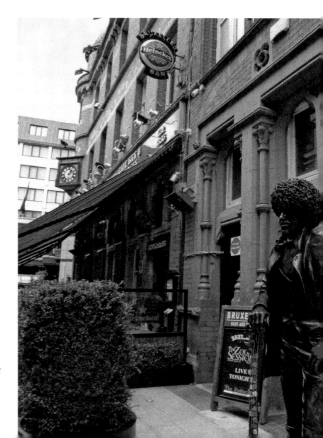

The life-sized bronze statue of Phil Lynott stands on the pavement outside the front of the Bruxells bar.

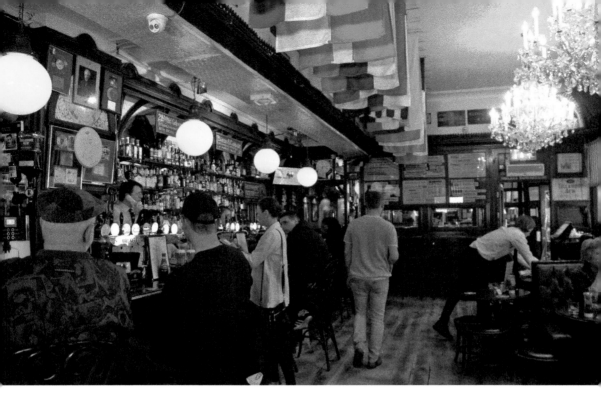

The interior of the Bruxells celebrates the spirit of nineteenth-century Dublin and the entry of Ireland into the European Union in 1973.

columns topped with ceramic panels elegantly representing the twelve signs of the zodiac, in addition to the flags of the European Union draping from the overhead canopy. The lower level of the pub has two bars: the Zodiac and the Flanders. During the 1960s and 1970s these emerged as the centre of Irish rock music where musicians such as Brush Shiels of Skid Row, Phil Lynott of Thin Lizzy, and the Rolling Stones gathered and attracted audiences such as Kris Kristofferson, Tina Turner, Mel Gibson and Lisa Minnelli. Phil Lynott even had his own snug at the back of the bar. The Flanders lounge now presents a display of memorabilia relating to the life and music of Phil Lynott, in addition to which a life-sized bronze image of Lynott, created by Paul Daly, was unveiled in the pavement outside the pub in 2005.

27. Cassidy's, No. 42 Camden Street

Cassidy's pub is a single-storey structure added to the front of a three-storey house that was opened in 1856. The building was once the headquarters of the *Freeman's Journal*. This was founded in 1763 and was the first national newspaper printed in Dublin. It only ceased publication in 1924 when it was taken over by the *Irish Independent*. The pub has a standard Victorian timber pub front, set between flat decorated uprights at either end. This has a central display window framed between a pair of slim rounded columns with a door on each side. Overhead the dark-coloured fascia is inscribed with the Cassidy name in gilded lettering with a narrow band underneath that reads 'Direct Wine & Brandy Importers'. An unusual feature is the

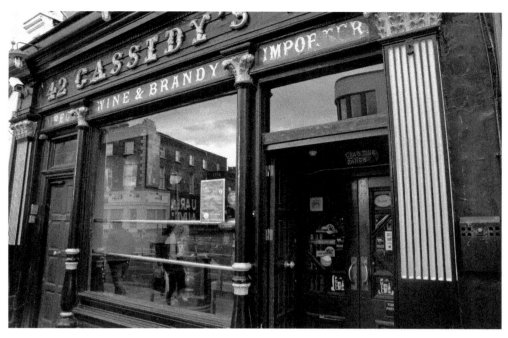

Cassidy's pub front is of Victorian timber with a central display window, rounded columns and a gold-coloured sign on the dark fascia.

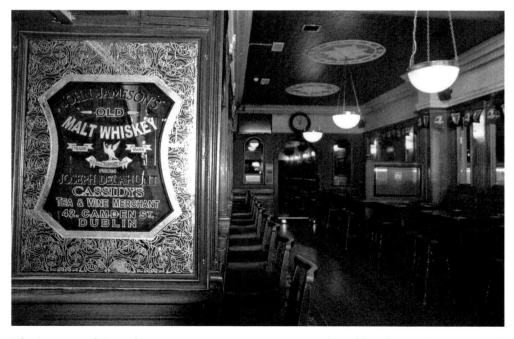

The interior of Cassidy's presents an interesting examples of hand-carved joinery, rich plasterwork, mirrors and advertising panels.

decorated grill parapet at roof level with a lion-mounted pedestal at each end. The interior of Cassidy's is long and divided into two sections by a triple arch. Here the elegant finishes include wood and coloured ceramic floor tiling, elaborately carved bar fittings, inbuilt seating, wood-panelled walls, embossed ceilings, moulded cornices, decorated ceiling roses, sport photographs and a selection of wall-mounted antique advertising mirrors. Halfway along the interior is an intricately decorated roof light with colourful semicircular and geometric images. The pub has a plainly decorated beer garden at the rear.

In 1995 Bill Clinton, then president of the USA, expressed a wish to visit a Dublin pub for a pint and it was decided he should visit Cassidy's. President Clinton's mother, whose maiden name was Virginia Cassidy, is a relative of the present owner. Cassidy's from all over Ireland were invited to the pub in what turned out to be a family affair. On the occasion a point was made of the president having a pint of Murphy's stout, although this was specially provided by the Murphy brewery on the day of the visit only as Cassidy's normally serve Guinness.

28. Davy Byrnes, No. 21 Duke Street

Davy Byrnes was established by Richard Span in 1722 and was purchased by Davy Byrne in 1899 from a Munster and Leinster Bank sale. Byrne retired in 1939 and the pub was acquired by the Doran family, who refurbished the interior in a successful art

The street front of Davy Byrnes' pub, with its plate-glass window, rounded columns and 'Davy Byrnes' inscribed on the fascia.

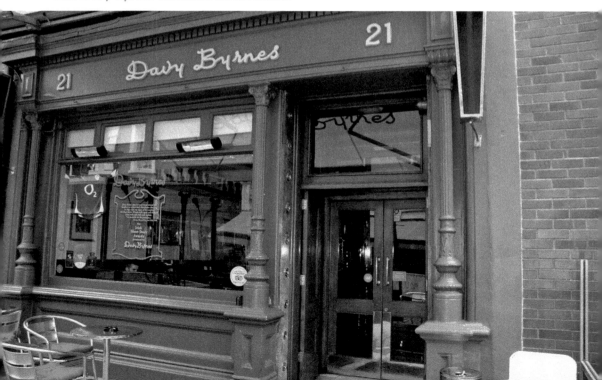

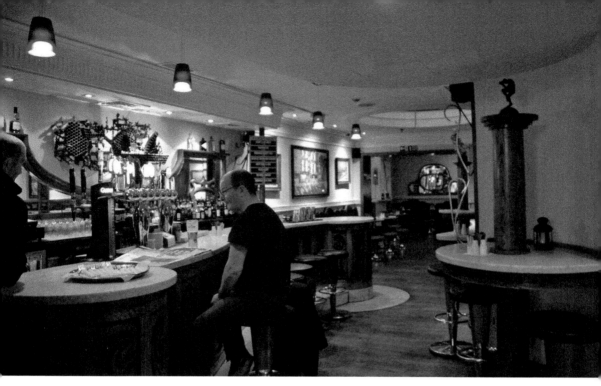

The long gallery of Davy Byrnes pub with its art deco features.

deco style around 1941. The narrow Victorian pub front opens onto Duke Street and has a large plate-glass window, moulded side columns and a decorated fascia with the name inscribed overhead. The pub also has a small external patio at the front. Today the interior incorporates tiled flooring, a curved marble-topped bar counter, curved shelving, pod-like bar stools, ornate coffered ceiling panels, wall-mounted sculptural elements and a stained-glass dome light. The interior also displays an excellent art collection, including a bust and portrait of James Joyce, a painting of Byrne himself and fine murals by Cecil French Salkeld, father-in-law of Brendan Behan.

Leopold Bloom, the fictional character in James Joyce's *Ulysses*, visited Davy Byrnes in the novel and described it as 'a moral pub'. He cashed a cheque in the bar and had a lunch that included a gorgonzola cheese sandwich and a glass of burgundy. This reference, and others, have attracted literary scholars and visitors to the pub ever since the publication of the novel in 1904, including writers such as Brian O'Nolan, Patrick Kavanagh, Brendan Behan. To mark this interest a bronze plaque has been set into the pavement just outside the door and a special celebration is held in the pub each year on 16 June to celebrate Bloomsday.

29. The Dawson Lounge, No. 25 Dawson Street

Undoubtedly the smallest pub in Dublin, if not the entire country, is The Dawson Lounge. This was established around 1840 and forms a small part of a narrow fronted four-storey nineteenth-century house. From the street the only evidence of the pub is the square cartoon-like sign over the extremely narrow entrance door, squeezed between

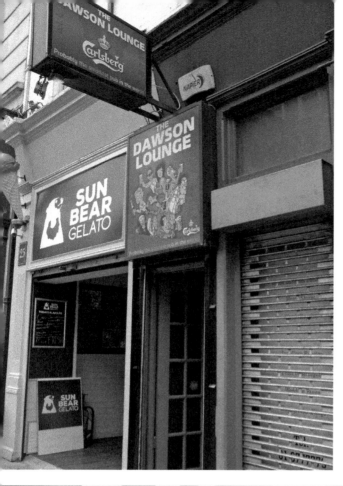

Left: The minimalist doorway and overhead cartoon sign marking the entrance to The Dawson Lounge.

Below: The small wood-panelled bar of The Dawson Lounge with ceiling-mounted flags in support of the Irish rugby team.

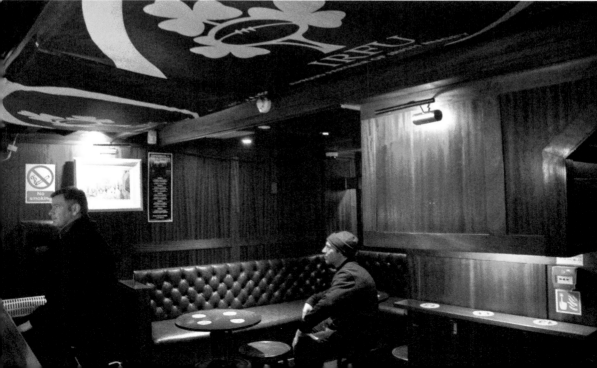

the two adjacent retail premises. Immediately inside the pub door, steep winding stairs descend to the one-room underground pub – like a secret gallery without any natural light. Here the pub has a small bar, wooden-panelled walls, a low ceiling and some inbuilt seating – room enough for the barman and around twenty customers.

30. Doheny & Nesbitt, No. 5 Baggot Street Lower

Donny & Nesbitt's is an outstanding example of a Victorian pub. It is positioned a short distance from Irish government buildings and is known as the haunt of politicians, government officials and newspapermen. The pub dates from around 1840 when it was operated as Delahunty's by William Burke. Later it was run by Philip Lynch, James O'Connor and Felix Connolly, before being taken over by Ned Doheny and Tom Nesbitt in 1962, who subsequently retired in 1990. The pub has a notable timber Victorian front. This has a pair of large display windows, set between decorated uprights, and an overhead fascia sign that reads 'Doheny & Nesbitt'. An unusual element is the distinctive brass sign beneath the windows that proclaims 'Tea and Wine Merchant'.

Internally, the pub has two sections: the original bar to the front where the nineteenth-century interior fittings remain largely intact, and the newer section at the

The timber Victorian pub front of Doheny & Nesbitt, with the large windowpanes and brass sign underneath that proclaims 'Tea and Wine Merchant'.

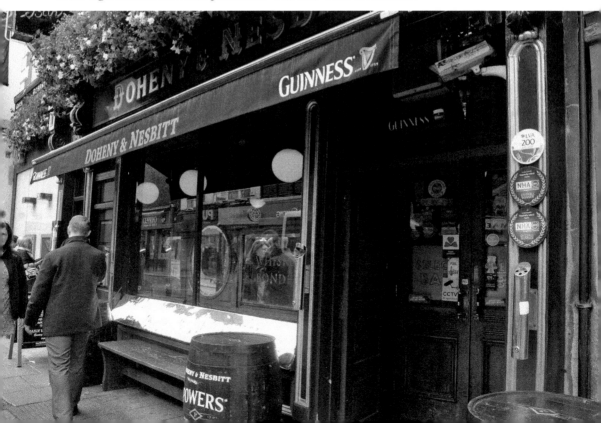

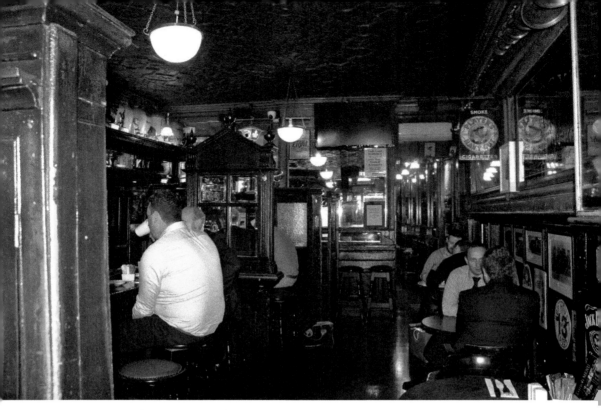

The Victorian front section of Doheny & Nesbitt with polished wooden bar counter, framed dividers, mirrors, advertising panels and embossed ceiling.

rear that is fitted out in a matching Victorian style. The front section of the pub includes polished wooden flooring, the wooden-framed bar counter divided into sections by framed dividers with mirror panels, the framed back bar, and the heavily embossed ceiling, while scattered around are items of bar memorabilia and antique vessels. The framed snug, complete with serving hatch, is near the entrance door and at the rear of the bar is an embossed mirror that once held the name 'O'Connor', but this was subsequently amended to 'Connolly' when the ownership changed. The rear section is fitted out with replica finishes and memorabilia carefully linked in style to the front section. The one difference is the sweeping arched roof light that introduces natural light into the back section. The pub prides itself in its extensive collection of whiskeys, including Powers, for example, with its curious crescent-shaped label that incorporates three swallows – a symbol that is said to date from the Crimean War of 1853–56. The story goes that Powers Distillery was awarded the contract of supplying small bottles of whiskey, called 'Baby Powers' to the British troops in the Crimea. The company dispatched a representative to the warzone to enquire what the troopers thought of the small bottles of whiskey. When asked his opinion, one squaddie is reported to have replied that the only fault with the Baby Powers was 'it contained only three swallows'. The company celebrated this remark by placing an extra label near the neck of the Baby Powers bottle. This included the image of three flying swallows spread across a Turkish crescent-shaped label.

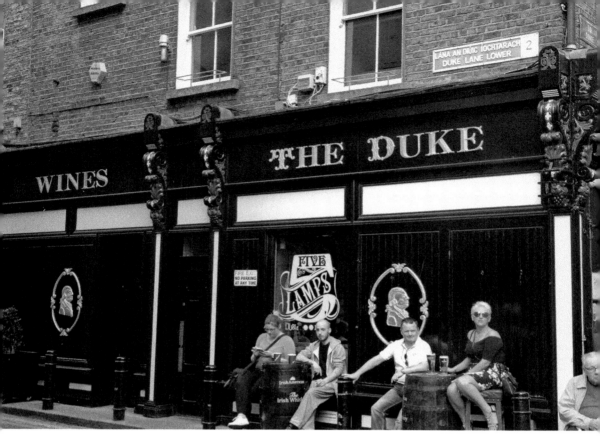

The Victorian elevation of The Duke pub with decorated uprights, plate-glass windows and gold lettering opens onto Duke Lane Lower and Duke Street.

31. The Duke, Nos 8–9 Duke Street

In 1822 Thomas Carroll was granted a pub licence for his premises at No. 8 Duke Street. Later, in 1838, the pub passed to Patrick Cullen, and later still to William Robinson in 1845. By this time Charles Bianconi had established the office of his coach company on the far side of the street. This held the exclusive licence to provide a coach service between Dublin and all towns in Ireland south of Carlow. Robinson realised the business potential of the arriving coach passengers and he went into partnership with Patrick Behan to open a boarding house next door to the pub. In 1852 Robinson sold the pub to Bernard O'Donohoe, who combined the two premises and operated it as the National Hotel and Tavern with gaming rooms above. This period saw the emergence of the Tavern Token arrangements. Under this, the owners of hotels and taverns provided tokens for patrons to indulge in gaming; however, such games were played for beverages rather than money and at the end of which the customer, should he win, could exchange his tokens for whatever drink he chose. The National Hotel and Tavern produced their own tokens in the form of coins embossed with a shamrock and a circle. From 1858 the premises was sold four times and ended up under the ownership of the Kennedy brothers in 1886. They abandoned the Tavern Tokens and renovated the pub to today's standards. Over a number of years the pub changed hands

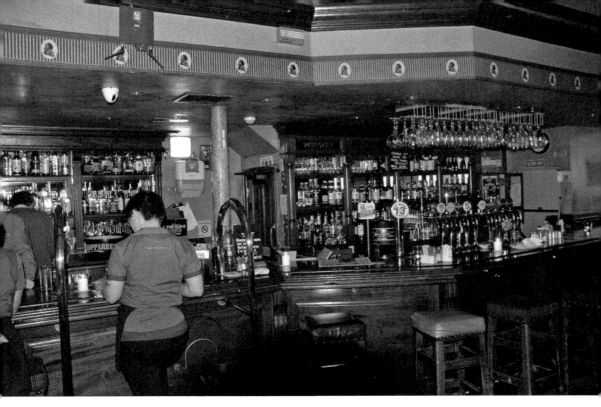

The restrained Victorian bar counter, back bar and overhead canopy of The Duke pub.

six more times, with a different name each time, until it was taken over by Larry Tobin in 1953 when it became Tobin's. In 1988 the current owner, Tom Gilligan, became the twelfth person in line to do so. He introduced the name the 'Duke' after the Duke of Grafton and the street of the same name.

The Victorian elevation of The Duke pub, introduced by the Kennedy brothers, takes advantage of the corner position linking Duke Street and Duke Lane Lower, with decorated uprights, plate-glass windows, a continuous fascia and blank panels – the latter offering gold coloured silhouette images of The Duke. Externally, a partially enclosed patio stretches along the Duke Street footpath. The Victorian imagery is more restrained inside. Plain columns divide the interior into interesting spaces with the wooden framed bar counter extending along one side. Above the counter is a projected wooden canopy faced with a pattern of silhouette images of the duke.

32. The Gravity Bar, Guinness Storehouse, St James's Gate Brewery

The Gravity Bar, which opened in 2000, sits on top of the Guinness Storehouse and is part of the Guinness St James's Gate Brewery complex in James's Street. The storehouse is seven storeys high and was built to house the operation of the Guinness fermentation process. The elaborate, steel multistorey framed building – in the Chicago style – is reputed to be the earliest example of the use of a steel-framed building in the British Isles when it was built in 1902. The steel frame was completed first and the red-brick walling was erected later. The building became redundant in 1985, following which it

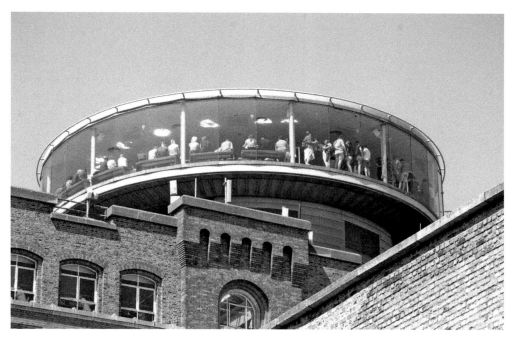

The glass circular 1997 Guinness Brewery Gravity Bar perched on the roof of the seven-storey 1902 storehouse.

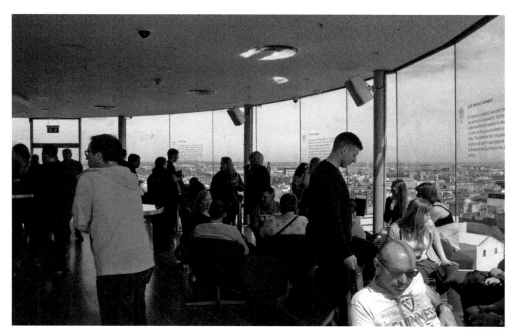

The glazed interior of the Guinness Brewery Gravity Bar offers a 360-degree panoramic view of the Dublin skyline.

was refurbished as a visitor centre for the brewery in 1997. This involved cutting out the central core of the building and filling it with a tall full-height atrium, the spatial form of which was inspired by the shape of a giant pint glass – a reference to the 'pint of Guinness'. The architects were RKD. A unique feature of the development was The Gravity Bar, perched on the roof of the original structure. This is circular in shape, with a polished wooden floor, flat ceiling and extends dramatically out over the brick edges of the original storehouse. The perimeter walling is totally glazed and offers a 360-degree view over the Dublin skyline, a superb visual experience – appropriately referred to as the 'Bar in the Sky'. An unusual aspect of the bar is that visitors are required to pay a fee to enter the visitor centre prior to entering The Gravity Bar.

33. Grogan's, No. 15 William Street South

Grogan's, also called the Castle Lounge, lies at the junction of William Street South and Castle Market and was opened in 1899. It is positioned diagonally across the street from the Powerscourt shopping centre with a pub front that wraps around the corner. The William Street front is standard rendered Victorian with decorated side framing and an overhead fascia. At some period in the past the original Victorian window and door were replaced with a plain twentieth-century form, subdivided into small panes. Round the corner, the gable of the Castle Market side of the pub is rendered and plain. The interior of the pub is long and narrow with a 1970s-style décor, and is divided into

The rendered pub front of Grogan's pub. The original Victorian windowpanes were replaced with small panes during the twentieth century.

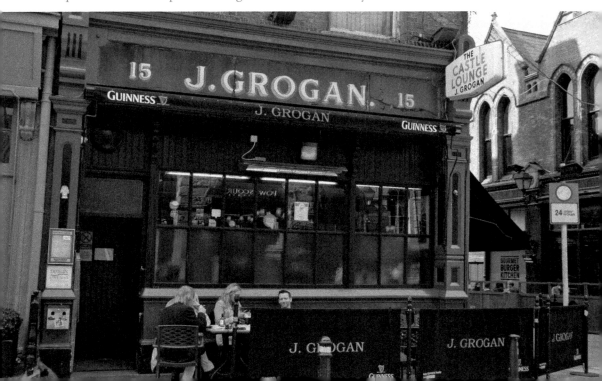

The plain twentieth-century interior panelling of Grogan's pub offers hanging space for traditional and modern artworks.

two sections by a wooden partition. There is a plain wooden bar counter on one side with undecorated timber sheeting on the walls. Unusually, the pub interior doubles as a picture gallery. Here the walls are hung with traditional and modern artworks, all for sale, as well as stained glasswork. The pub also has a large outside seating area – on both William Street South and Castle Market. During 1973 the notable Dublin barman Paddy O'Brien moved from McDaid's pub in Harry Street and took over the management of Grogan's. Such was O'Brien's reputation and skill as a barman that many of the patrons of McDaid's, such as the writers Brendan Behan, Patrick Kavanagh, Liam O'Flaherty and J. P. Dunleavy, moved their patronage to Grogan's and the pub acquired the reputation as a literary pub. The writer Brian O'Nolan, writing under pseudonym FlannO'Brien, even mentions the pub in his novel *At Swim-Two-Birds*.

34. The Hairy Lemon, Nos 41–42 Stephen Street Lower

The Hairy Lemon has a nineteenth-century origin and is positioned on the corner of Stephen's Street Lower and Drury Street. It takes up the ground floor of the nineteenth-century building and extends around the corner into Drury Street. The interior display panel attributes the unconventional name of the pub to the nickname of a dog catcher who operated in the neighbourhood during the 1940s. He is reputed to have had a lemon-shaped head and a stubby beard, much like a gooseberry. The choice of name may also have been influenced by the name of the nearby Lemon Street. The pub previously operated under several names, including the William Tell and the Pygmalion.

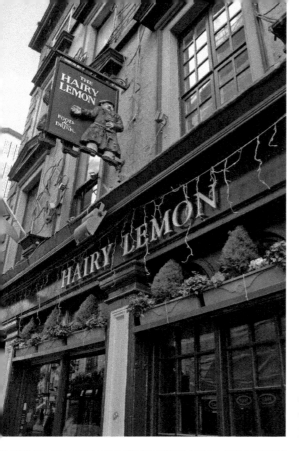

The rendered and framed pub front of
The Hairy Lemon, with the overhead
hanging advertising sign.

The partial double-storey section of
The Hairy Lemon with its collection
of old signs, bicycles, jars and exposed
brickwork.

The wrap-around bar front has large windows with small panes set between framed uprights with a corner door and a continuous overhead fascia bearing the pub's name. The pub also has an overhead sign with the name and an image of the hairy lemon character. The internal atmosphere of the pub is decidedly antiquarian. It has a series of cosy bars and alcoves that include a double-height ceiling in one section and an exposed brick archway separating one section from the other. Cast iron columns are another feature of the interior. Elsewhere the walling is a rich mixture of coloured render, wooden partitions and exposed brickwork, above which the ceiling varies from painted plasterwork to wooden beams. Apart from the framed wooden bar counter, the overall feature of the interior is the array of elements that cover almost the entire walls and ceiling. These include old advertising images, photographs, memorabilia and even a pair of old-fashioned bicycles. In recent years the interior of the pub has appeared in the film of Roddy Doyle's book *The Commitments*. Upstairs, the lounge area is much more restrained, with plain decorated walls and ceilings.

35. Hartigan's, No. 100 Leeson Street Lower
Hartigan's pub seems to have been around since the early eighteenth century and was taken over by Alfie Mulligan in 1974. Mulligan came from a farming family and served his apprenticeship as a barman in Glasgow. Following this he returned to Ireland

The stained-glass panels and tall rounded windowpanes of Hartigan's pub provide a view of the outside streetscape and an attractive backlight to the inbuilt window seating.

The dark colouring, stained-glass panels and rounded windows of Hartigan's pub front blend well into the adjoining eighteenth-century streetscape of Leeson Street Lower.

where he held the position of manager in Mooney's pub in Phibsboro. On one occasion he fell ill with an ulcer and ended up in St Vincent's Hospital, then on the corner of St Stephen's Green and Leeson Street. This was the era before mobile phones and so Mulligan went into an adjoining pub in Leeson Street to telephone his wife and explain where he was. He was, however, very impressed with the pub and within a year he had taken it over. During the early period Hartigan's pub was located diagonally across the road from University College Dublin and it became extremely popular with the student body, who gave it the nickname 'Hartos'. Even when the hospital and college moved to Elm Park and Belfield respectively, its popularity remained and Mulligan continued to serve his customers until he recently passed away aged ninety.

Today the pub remains as Hartigan first found it. The modest but attractive wooden Victorian front has three round-headed windows, behind which are three stained-glass panels containing the initials 'T, J and L', a reference to a previous owner, Thomas Joseph Lynch. Overhead, the plain fascia has the Hartigan name in gold-coloured lettering. In a later addition, the letters 'A' and 'M' form part of a metal grill over the door as a reference to Alfie Mulligan. Inside, the pub has a plain bar counter with the equally plain back bar. Elsewhere, the most notable feature is the inbuilt window seat, backlit by the curved windowpanes and stained-glass panels. Elsewhere, the walling has an interesting display of sporting, medical photographs and images, and a distinctive low-key atmosphere.

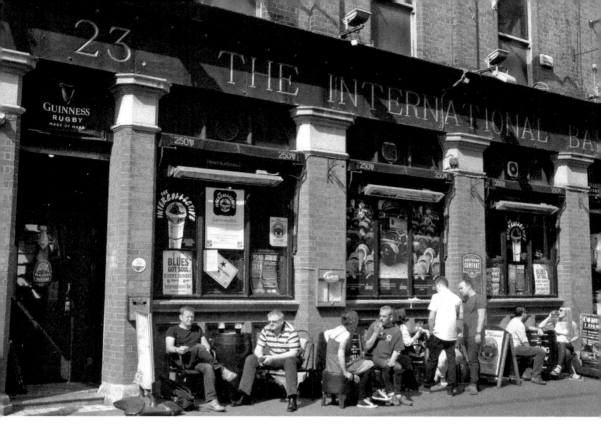

The Victorian red-brick piers, stone tops, large windows, dark fascia and gold-coloured lettering of The International Bar.

36. The International Bar, No. 23 Wicklow Street

The origins of The International Bar date from 1854 when John Dunne held the pub licence. In 1866 the pub was sold to the O'Donohoe family. They introduced the name 'The International Bar', which the pub has retained, and it has remained in the ownership of the O'Donohoe family since then. The pub is mentioned in James Joyce's *Dubliners*, a volume of short stories published in 1914; however, Joyce refers to the pub not as the International Bar, but by the name of the owner Ruddy O'Donohoe: 'Opposite Ruddy O'Donohoe's Master Patrick Aloysius Dignam … went along warm Wicklow Street dawdling.' The pub forms the ground level of a four-storey red-brick Victorian building that marks the corner of Wicklow Street and St Andrew Street, opposite The Old Stand. The pub front stretches around the corner in a series of large windows set between slim stone-capped red-brick piers, above which the deep dark-coloured fascia has the name of the pub inscribed in gold lettering.

The Victorian interior of The International Bar is long and narrow with the polished granite-topped bar counter and its brass foot rest extending along one side. Behind is one of the most remarkable back bar panels to be found in Dublin, which features the river gods of Ireland exquisitely carved in wood. Overhead, the material of the embossed ceiling is papier mâché. The floor has colourful mosaic tiling including the O'Donohoe family crest, and the walls present a display of old photographs, antique

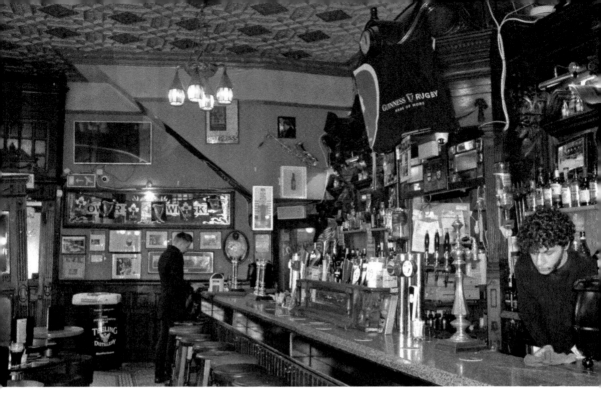

The interior of The International Bar is long and narrow, with the bar counter and the elaborately carved back bar panel stretching along one side and embossed ceiling overhead.

advertising mirrors and a range of antique memorabilia. Unusually, the premises operate on three levels: the bar is on the ground level, a comedy venue is on the first floor, and there is a theatre in the basement. Notable patrons of the pub have included the writers Bendan Behan, J. P. Dunleavy and Patrick Kavanagh, as well as the politician Michael Collins and the artist Harry Kernoff.

37. John Kehoe, No. 9 South Anne Street

Kehoe's pub, which dates from around 1803, is on the corner of South Anne Street and Duke Lane Upper, just off Grafton Street. The pub has a corner entrance and acquired the name 'Kehoe' in 1903. The Victorian pub front on South Anne Street has a large triple-panel window with the corner door to one side – positioned between slim uprights with highly decorated tops. The Duke Lane Lower side is narrower and has an imposing decorated wall poster extolling the charm and beauty of the John Kehoe's pub between the corner door and a side door, while the overhead fascia extends on both streets and is inscribed with the name 'John Kehoe'.

Internally, Kehoe's has a sequence of bars, nooks, crannies on several levels in addition to snugs and is notable for its distinctive Victorian atmosphere, including cast-iron columns and embossed ceilings. A long wooden bar counter extends along one side, behind which the elaborate Gothic-style back bar has slim rounded pillars, gables and curves. Particularly notable is the bank of commodity drawers near the

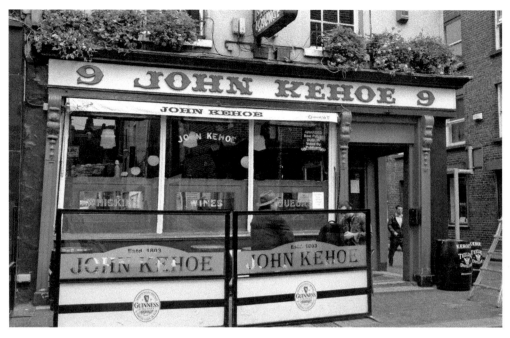

The large pub front windows, corner doorway and fascia of Kehoe's opens onto South Anne Street.

The retained living room of the former publican John Kehoe – now part of Kehoe's pub.

main entrance. These date from the past and once held supplies from the pub's past trade in spices and groceries. Elsewhere around the pub are displays of stained glass, glazed partitions, dividers, mirrors, photographs, old advertisements and antique equipment. Notable customers of Kehoe's in the past have included the writers Patrick Kavanagh, Brendan Behan and Flann O'Brien. Prior to his death the owner, John Kehoe, lived in his apartment above the pub and when he died the new owner decided to incorporate the apartment into the pub. In an enlightened move it was decided that the apartment would remain unaltered, and thus retains its domestic features such as decor, furniture and fireplaces, so that today this section of the pub offers a charming residential atmosphere of the past.

38. Kennedys, Nos 31–32 Westland Row

Kennedys pub dates from 1850 according to the advertising sign behind the bar. The pub is positioned on the Lincoln Place and Westland Row corner on the ground-floor level of an eighteenth-century Georgian house, immediately adjacent to the back entrance of Trinity College. In 1862, John McGauran ran the pub and also operated as a grocer. In an unusual literary connection, the writer and playwright Oscar Wilde lived on Merrion Square nearby and stacked shelves in the grocery section and worked

The terracotta-faced pub front and entrance arches of Kennedys.

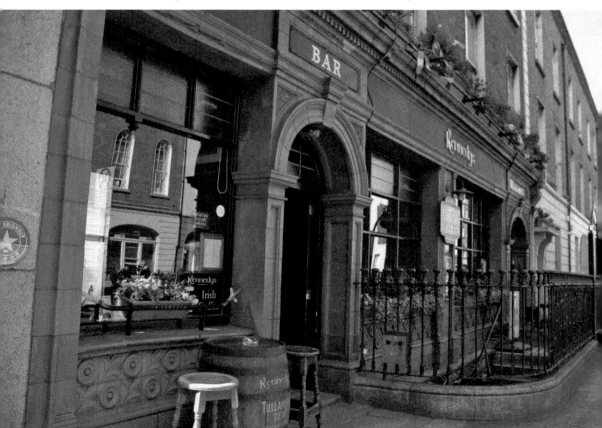

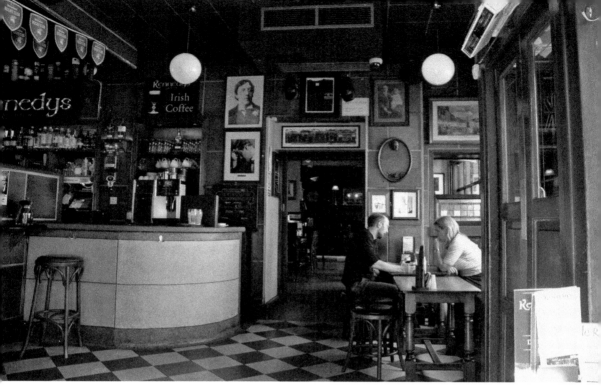

The black and white floor tiling, plain tiled wall, ceiling tiles and wall-mounted photographic images of Kennedys pub.

as a lounge boy in the bar. In addition to Wild, Samuel Beckett and James Joyce also patronised Kennedys. In addition to taking a drink in here, Joyce also included a reference to the pub in *Ulysses*, although the book refers to the pub as Conway's. To mark this reference, Kennedys hold a Bloomsday breakfast of liver and kidneys on the 16 June each year with the customers all in Edwardian dress. The event is held in association with Sweeney's Pharmacy, located across the road from the pub, which is also mentioned in *Ulysses*.

The wrap-around bar front is faced with finely crafted terracotta work, with wide windows subdivided into small panes, ornamental metal railings to the basement area and a pair of particularly elaborate entrance arches opening onto Westland Row. The Lincoln Place elevation is plain except for a wall mural that highlights the pubs literary patrons such as Wild, Joyce and Yeats. The interior of the pub has three sections, each fitted out in a restrained modern decor. This includes a marble-topped bar counter with a mirrored back bar, black and white floor tiling, plain walling and flat ceiling tiles. Wall hangings have been selective and limited to images of individuals and places, such as Oscar Wilde and medieval Dublin.

39. The Long Hall, No. 51 South Great George's Street

The Long Hall received its first licence in 1766 and during the nineteenth century was run by a succession of owners including Henry Mailey in the 1830s, Patrick Parker in 1857 and Joseph Cromien in 1864. During this period the pub acted as a meeting place

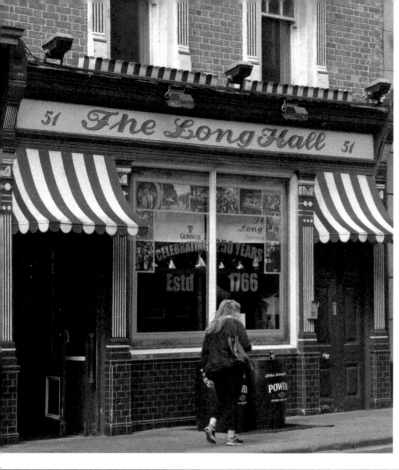

Left: The Victorian pub front of The Long Hall acts as an important aspect of the South Great George's Street streetscape.

Below: The ornate arched room divider leads to the rear section of The Long Hall.

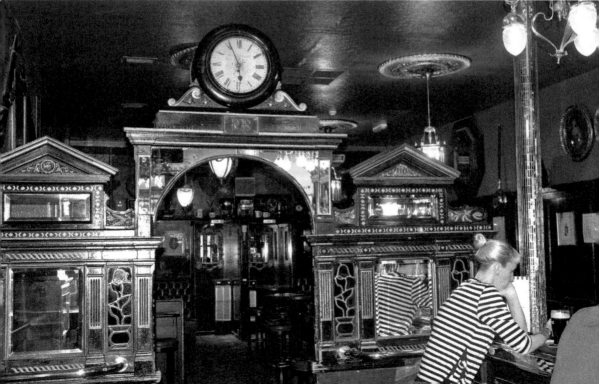

for the Fenians, the political organisation dedicated to ending British rule in Ireland, and the unsuccessful 1867 Fenian Rising was planned here. In 1866 the then owner was arrested for his Fenian activities and the pub was closed down for some time. By 1867 the pub was owned by Robert Reynolds and Patrick Dolan. Dolan eventually bought out his partner and around 1881 he refurbished the pub in a Victorian style that survives to the present. The narrow pub front has a double plate-glass window and two flanking panelled doors – one to the pub and the other to the upper floors of the building – all set between slim decorated uprights, above which the fascia has the scripted pub name.

Internally, Dolan's narrow but long layout has considerable charm and includes coloured-painted walls, handcrafted wooden carving, ornate glass, mirrors, framed bar counter with brass trims, and framed back bar, as well as the embossed ceiling with delicate ceiling roses. In 1912 William Fitzpatrick took over the pub and it was he who installed the delightful arched and framed divider and clock that leads to the back part of the pub. The name 'The Long Hall' possibly dates from this period and comes from the long narrow hall at the side of the pub that led to the upper floors of the building. At one time this doubled as snug – hence the name – and although complete with a serving hatch from the bar, it is no longer part of the pub. Patrick O'Brien bought the pub in 1941 and when he died in 1966 he left the pub to the staff in his will. The staff decided they did not want the responsibility of running the pub and put it up for sale. The day of the auction was warm and the present owner happened to be passing along South Great George's Street when he decided to drop into the pub to have a drink. He was admiring the place when he was informed by the barmen that the pub was being auctioned that day. He had never been in the pub before, but he was so impressed with what he saw that he went along to the auction and bought the pub. Today the pub is still operated by the purchaser's family. More recently, in 1982, the pub acted as the scene for the Phil Lynott recording of the hit song 'Old Town'.

40. The Long Stone, No. 11 Townsend Street

Although dating from the eighteenth century, The Long Stone pub was refurbished in the 1990s in an imagined Viking-inspired approach. The name of the pub is derived from the Viking stone, or 'steyne', that stood nearby. This was originally erected by the Vikings in the River Liffey estuary during the ninth century to mark their place of settlement. The area was reclaimed and built over during the seventeenth century, hence the name of the street – Townsend Street. The stone was removed in 1794. In 1986 a granite replica of it was erected near the pub in the place where it originally stood. This stands over 3 meters high with small facial image of Ivar, the ninth-century Norse king, and a small female face. The wide wooden Victorian-style pub front has a central door, two wide display windows with slim flat columns and a fascia with the pub name. The windows are divided into three panes with additional squared framing behind. Inside, the pub the accommodation includes the large bar, a high-level gallery, a snug, and a partially roofed external beer garden. The vibrant Viking styling includes wooden floors and high-panelled ceilings, rough-coloured wall finishes, carved dark wood bar, intricately carved glazed and wooden panelling, carved columns, high-level circular windows, stained-glass panels, illuminated wall hangings, antiques and pub

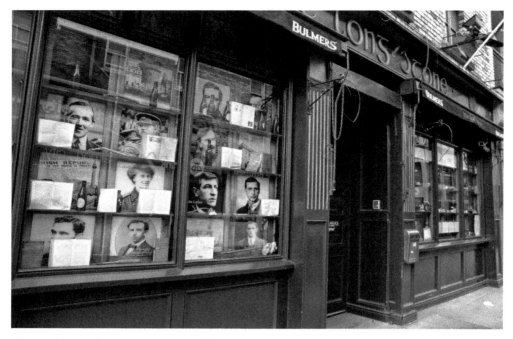

The wide wooden Victorian-style front of The Long Stone pub has a central door and two wide display windows, slim columns and a fascia with the pub's name.

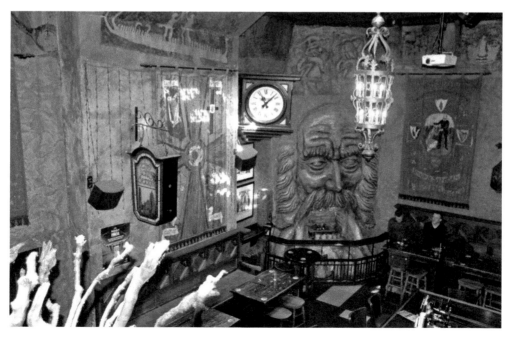

The tall Long Stone pub with the Viking imagery includes rough walling, woodwork, wall hangings and the dramatic fireplace featuring the gigantic face of a Viking god.

curios. The most remarkable feature of the pub is the fireplace. This consists of a gigantic three-dimensional mask of a fierce-looking Viking god, with the fire set into the open mouth. The upper gallery with the exposed timber roof structure is reached by a wooden stairs in one corner and follows the styling of the ground level.

41. McDaids, No. 3 Harry Street

The McDaids building served a number of uses before it emerged as a pub around 1873, such as the Dublin City Morgue and a Moravian chapel. In 1901 John Nolan was the publican and thirty-five years later John McDaid bought the pub from William Daly, put his name over the bar front and ran a small undistinguished pub. A year later, the popular barman Paddy O'Brien suggested to McDaid that the pub would benefit from being opened up to attract more patrons and, to his surprise, McDaid did this. Around the same time the publisher John Ryan became one of the new customers. He ran a literary magazine, *Envoy*, and usually arranged to meet with the writers and journalists who contributed to it in McDaids. This gradually drew a range of literary people to the pub, to the extent that by the 1950s McDaids had become the established literary haunt of writers such as Patrick Kavanagh, Brendan Behan, Flann O'Brien, Austin Clarke and P. J. Dunleavy. In 1972 the pub came up for sale and Paddy O'Brien tried to buy it. He was outbid, however, by an English company who wished to own

The unusual art deco elevation of McDaids pub includes a mixture of elements such as arches, circles, slender columns, the date of its establishment and a gold-coloured name.

The back bar of McDaids pub includes mirrors, lighting, decorated framing and the colourfully tiled name and date panel.

a pub with a strong literary tradition. Having failed in his bid, O'Brien then moved to the nearby Grogan's where he took over the management of the pub. However, the McDaid customers followed O'Brien to Grogan's and McDaids reputation as a centre of Dublin literature dwindled.

McDaids has an unusual art deco-style front. This has a central curve-headed doorway, arched display windows on both sides, slim pillars and square upper panes, above which the plain fascia has the gold-coloured name 'McDaids'. The interior of the pub is small, attractive and memorable. This has a framed and tiled wooden bar counter and arched, carved back bar, the latter with mirrors and a colourful tiled name panel. The bar also has a broadly coved ceiling, painted walls displaying portraits of writers, books, old advertising panels and glazed memorabilia panels, as well as inbuilt seating with tiled and wooden wall panelling. Today the pub is unusual in that it serves no bar food. It did, however, achieve an unexpected level of publicity from the film *Gone Baby Gone*, where in one scene the actor Casey Affleck is wearing a T-shirt with the image of McDaids pub.

42. John Mulligan, No. 8 Poolbeg Street
Mulligan's began as a 'shebeen' (an unauthorised drinking venue) in Poolbeg Street, first becoming authorised in 1782. John Mulligan took over the pub in 1854 and in 1880 rebuilt the premises in its present form. Later, in 1890, the area of pub was

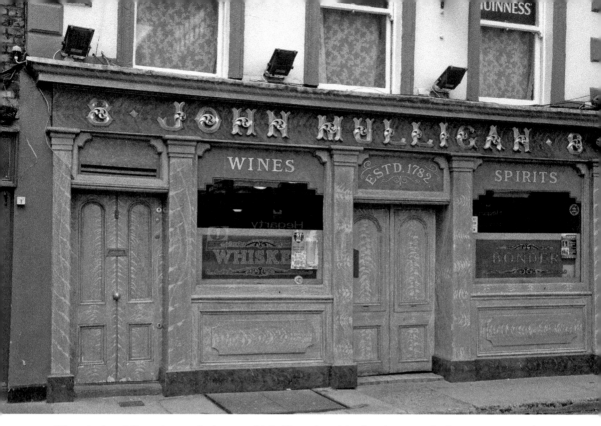

The timber Victorian pub front of Mulligan's with the doors, windows, rectangular uprights, fascia and gold-coloured name.

extended into the adjoining premises. In 1932 Mulligan sold the pub to Mick Smith and it later passed into the ownership of the Cusack family. In 1945 John F. Kennedy, the future president of the USA, visited the pub as a young journalist. He was so impressed with the pub that he promised he would later return, but never did. The pub was popular with journalists from the *Irish Press* until the closure of the paper in 1995 and it was also popular with the cast and patrons of the nearby Theatre Royal music hall until it was demolished in 1962. The pub also makes an appearance in James Joyce's 1914 short story collection *Dubliners*.

The notable timber Victorian pub front of Mulligan's remains as it was built in 1880, complete with removable shutters. This includes the central doorway, two display windows and a side door – all spaced between five rectangular pillars. Overhead, the continuous fascia has the name 'John Mulligan' in decorative gold lettering. The fanlight panel over the door announces the 1782 foundation of the pub. Later, as the area of the pub expanded, the pub front was extended along Poolbeg Street in a number of different styles. Internally, the pub layout has a sequence of rooms, one leading to another. Here the Victorian pub atmosphere prevails throughout, with dark-coloured wood, timber beams, curved bar counters, mirrors, leather seating, timber wall panelling, embossed paper on walls and ceilings, moulded ceiling cornices, and antique theatrical and advertising posters. The pub has remained popular with

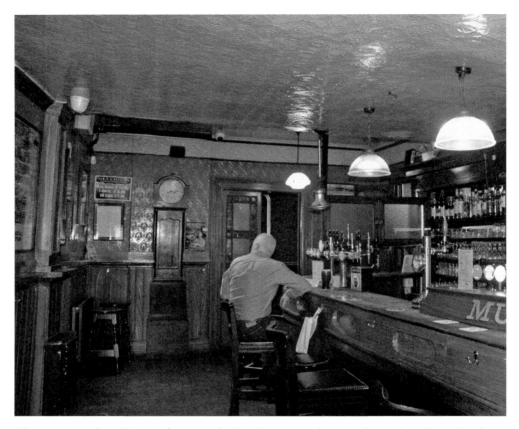

The interior of Mulligan's features dark-coloured timbers, embossed walls and ceilings and a grandfather clock in the background.

locals and visitors. One American visitor in particular, Billy Brooks Carter from Texas, was so enamoured with Mulligan's that he wished to be interned in the pub when he died. When he died, his ashes were brought to Mulligan's and today they rest inside the pub's grandfather clock – his own personal mausoleum.

43. Neary's, No. 1 Chatham Street

Neary's of Chatham Street lies a short distance from Grafton Street, one of the main shopping arteries of Dublin. The pub dates from the mid-nineteenth century, when it operated as Casserly's Tavern. In 1887 the pub was bought by Thomas Neary and the Neary name has remained above the door ever since. In 1871 Gaiety Theatre opened in nearby South King Street, with the stage door in Tangier Street positioned directly opposite the rear entrance to the pub – a facility that encouraged a theatrical patronage including twentieth-century notables such as Maureen Potter, Jimmy O'Dea, Ronny Drew, Michael McLiammoir and Richard Harris. In the 1970s the pub patrons included poets Austin Clarke, Mary Lavin, Thomas Kinsella and Tom Kilroy. Externally, Neary's has a sequence of vertical windows and doorways spaced between brick pillars

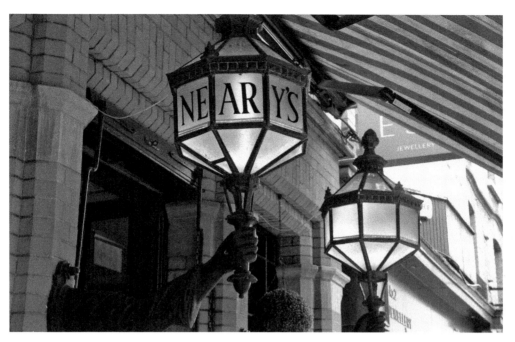

The decorative lamps carried by metal supporting arms highlight the entrance to Neary's pub.

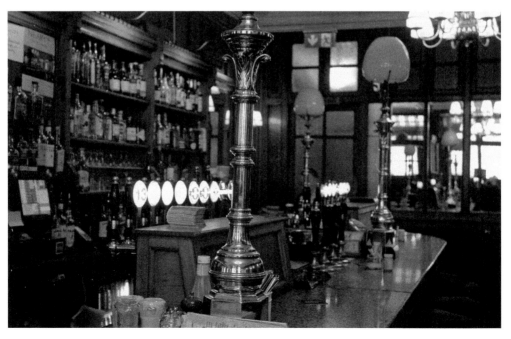

The polished granite countertop of Neary's with the brass lamps and the ebony and brass pump handles.

with stone trimming. The outstanding feature of which is the pair of lamp brackets that flank the main door. These take the shape of metal arms that carry ornamental lamps inscribed with the Neary name. Inside, Neary's has a restrained Victorian or Edwardian atmosphere with the main bar and a small snug-like section – all with a touch of opulance. Here the elegant interior fittings include the marble-topped counter with brass countertop lanterns and framed back bar, rich timber wall panelling and screening, plastered ceiling with moulded cornices and splendid examples of artwork from the Dublin artist Harry Kernoff. Neary's is one of the few remaining Dublin pubs where the custom of white-uniformed barmen survives. Here the bar staff wear white shirts, black bow ties and black trousers.

44. O'Donoghue's, No. 15 Merrion Row

O'Donoghue's is perhaps the best known of all Dublin pubs, particularly in relation to traditional Irish music, with which the pub is closely associated. The premises was originally established in 1789 as a grocery and passed to Captain George Vaughan in 1837. Following this it had a succession of owners and in 1934 came into the possession of the O'Donoghue family. During the 1960s the pub emerged as the centre of Irish traditional music under the guidance of the O'Donoghue's and a host of singers and

The Guinness-themed black and white pub front of O'Donoghue's marks a prominent stand on Merrion Row between St Stephen's Green and Baggot Street.

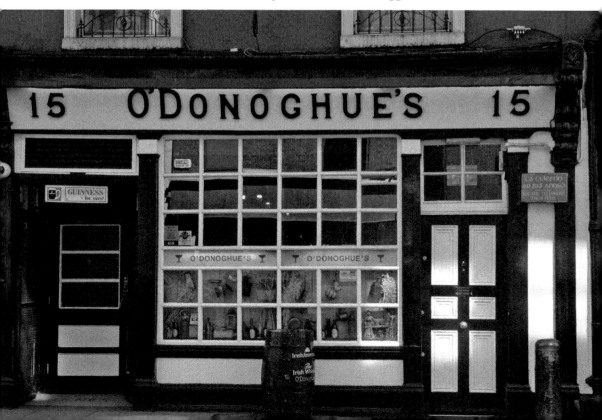

The otherwise plain walling of O'Donoghue's pub is covered with illustrations of Dublin's notable traditional musicians and singers, particularly the Dubliners.

musicians made an appearance. Among those appearing were Seamus Ennis, Finbar Fury, Sweeney's Men, Christy Moore, Ronny Drew and the Dubliners. In 1965 the pub had the unusual distinction of being the subject of a folk opera: 'O'Donoghue's Opera'. This starred the Dubliners folk group and was made into a film – still available on YouTube. In 1977 Dessie Hynes took over the pub from Paddy and Maureen O'Donoghue and the pub is currently run by the Barden family.

O'Donoghue's takes up the ground floor of a four-storey Georgian-style house that fronts onto Merrion Row. The bar front has a large display window divided into small white-painted square panes, flanked by a pair of black and white doors, all spaced between slim black-painted uprights. Overhead, the black-coloured O'Donoghue name is painted on the white fascia. The interior of the pub suffered a fire in 1985 and, although reinstated, little of the original interior fittings survives. This has a narrow front and back section with the wooden-panelled bar counter, carved division panels and back bar extending along one side. The interior is plain elsewhere. Sections of the walls have wooden sheeting, but the main feature of the pub interior is an extensive range of photographs, paintings and mirrors that almost block out the wall surface. Notable among these are images of the traditional musicians and singers who entertained in the pub, such as individual members of the Dubliners folk group. Today traditional musicians still play their guitars, flutes, fiddles, tin whistles and uilleann pipes to the patrons of the pub. The pub is also provided with a large beer garden in the covered laneway with access from the pub.

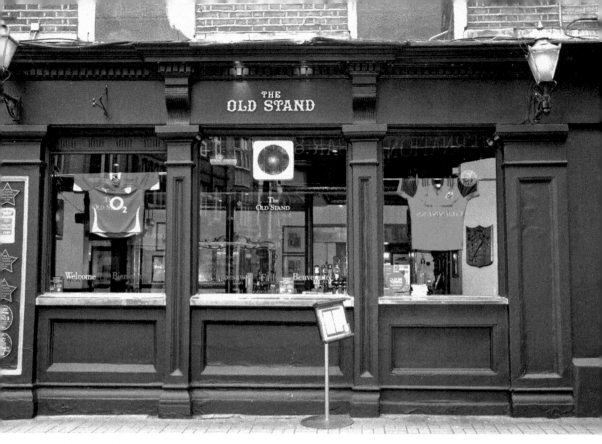

The pub front of The Old Stand pub, with the small gold-coloured name painted on the dark fascia and the display of Rugby jerseys.

45. The Old Stand, No. 37 Exchequer Street

The Old Stand, once called the Monaco, stands at the corner of Exchequer Street and St Andrew Street, a busy junction. The pub is reputed to have its origins in the seventeenth century, and in 1817 came into the ownership of James McClean who engaged in the provisions and licensed trades. Later traders included Lewis Martin in 1840, Daniel Flood in 1851, Michael O'Brien in 1868, John Cox in 1855, Thomas Ryan (tea, wine and spirit merchant) in 1900 and the Doran family in the 1950s. Around this time the name was changed from the Monaco to The Old Stand. This new name was borrowed from a section of the former Lansdowne Road Rugby grounds – now demolished and recently rebuilt as the Aviva Stadium. In many ways the name reflects the sporting clientele of the pub, noticeable from the range of rugby jerseys on display. The pub is slotted into the ground floor of a Georgian house with a pub front that extends round the corner. This has large display windows and a doorway set between framed uprights, all painted dark grey – not quite the Guinness-themed black. An unusual feature is the tiny gold-coloured name in the otherwise blank fascia. Internally, the two-roomed pub has a restrained but bright soft-coloured Victorian decor. The principal feature is the central-framed and panelled timber horseshoe bar counter with bright bar taps. Behind this is the dark-coloured and highly decorative

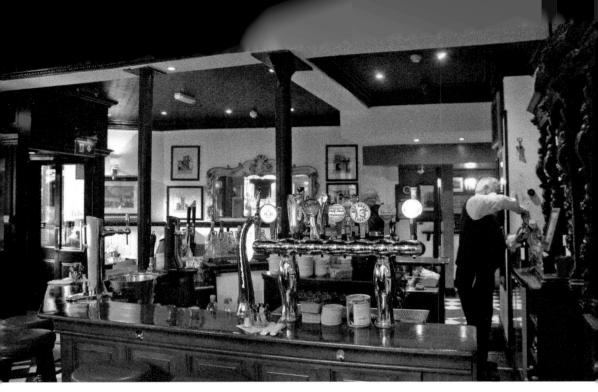

The central framed and panelled horseshoe-arranged bar counter and the restrained background of The Old Stand.

Welsh dresser-style back bar display cabinet. Elsewhere, the plain pale-coloured walls feature displays of framed sporting, historic images and mirrors.

One of the more notable patrons of the pub in the past was Michael Collins, one of the leaders of the nationalist movement. During the War of Independence between 1919 and 1921 Collins had his office nearby in Andrew Street and, as well as being a customer, he frequently held political meetings in a back room of the pub. Today a plaque and framed portrait of Collins hangs in an honoured place in the front bar.

46. O'Neill's, No. 2 Suffolk Street

The building fabric of O'Neill's pub wraps around the corner of Essex Street and Church Lane and was operated by the Hogan family until 1875 when it was purchased and renamed by M. J. O'Neill in 1927. O'Neill began work on rebuilding the four-storey pub to the design of the architect George P. Sheridan the following year. Sheridan arranged the front elevation of the building into a sequence of picturesque elements that followed the curved street line and included individual Victorian pub fronts, a mixture of stone and coloured brickwork, Tudor-like bay windows, street-facing roof gables and a projecting three-faced clock. Today the vibrant building acts as a backdrop to the bronze statue of Molly Malone on the far side of Suffolk Street. Internally, the pub features a complex arrangement of attractive spaces on several levels with wooden interconnecting stairs, curved bars, leather seating, polished hardwood beams, elaborate wall panelling, framed wall-mounted images, glazed presentation

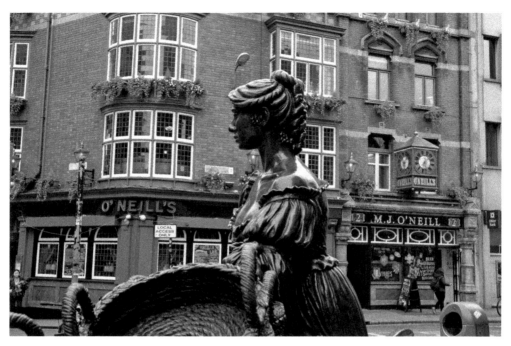

The charming front of O'Neill's pub with its many architectural elements including individual shopfronts, coloured brickwork, projecting bay windows, leaded lights, and three-faced clock combine to act as a backdrop to the bronze statue of Molly Molone.

The interior of O'Neill's pub has an arrangement of attractive interconnected spaces, changing levels, antique displays and polished wooden surfaces.

cupboards, coloured glasswork and framed wooden ceilings. O'Neill was noted for the efficient running of the pub, in which service to the patrons was paramount. The story of one regular satisfied customer exemplifies this. This was Maggie, a stallholder from the nearby Moor Street market. Maggie, it seems, was uncertain as to the existence of an afterlife, but just in case she often expressed the wish to have some Guinness buried with her when she died to ease her on her way. On the day of her funeral her wishes were forgotten until the last moment. The route of the funeral to Glasnevin Cemetery was then diverted so as to pass Suffolk Street, where the hearse stopped outside O'Neill's pub. There the driver jumped from the hearse, rushed into the pub and bought two bottles of Guinness. These were taken to the cemetery and placed on Maggie's coffin as it was lowered into the grave.

47. Ryan's, Beggars Bush, No. 115 Haddington Road
The establishment of Ryan's at Beggars Bush dates from 1803, although it was not until 1913 that the pub came into the ownership of the family when Jack Ryan took over the pub and moved his family into the upstairs living quarters – a family connection with

The 1967 painting of the Beggars Bush terrace on Haddington Road, including Ryan's pub with the external cast-iron gas lamp immediately in front.

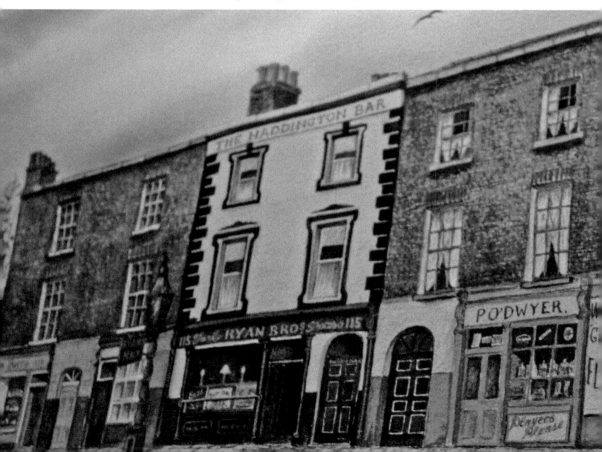

The cast-iron gas lamp featured in the 1967 painting of Ryans's pub in its restored position immediately in front of the pub.

the pub that still survives. At this period the pub was part of a parade of three-storey buildings with business premises at ground level that was positioned next door to the British Army's Beggar's Bush Barracks. A painting of the terrace dating from 1967 includes the pub, then named Ryan Brothers, and a sign at roof level reading 'The Haddington Bar'. An interesting detail in the painting is the cast-iron gaslamp standing in front of the pub.

In 1967 the Irish government decided to purchase the parade with a view to its demolition in order to provide a site for a National Concert Hall. The sale was completed and in the same year the terrace was demolished. In the case of the pub, the upper part of the building was demolished but the ground-level section was left standing. This was leased back to Jack Ryan on a temporary lease of one year, until such time as work started on the construction of the concert hall. One year later, on Easter Thursday, the government asked for the keys back as construction was ready to start. A few days later the keys were returned as the government were not ready to start building, and the temporary lease was extended for another year. Each Easter thereafter for the next twenty years the keys were collected on a Thursday and returned to Jack Ryan a few days later with another lease for another year. Finally, the Concert Hall project was abandoned in 1988 and the pub was sold back to the Ryan family, in addition to which they were able to purchase to entire site.

A new pub was then built using the old pub as a base. This development stretches across the site with the new double-storey brick building in a corner position. It was given a range of standard Victorian features including the timber shopfront opening onto both Haddington Road and Lansdowne Park, with the Ryan name prominently displayed on the fascia as well as tall curved windows on the first floor. Internally, the layout is arranged in a series of interconnected bars and lounges on both floors, incorporating Victorian design elements such as polished joinery and marble bar counters. A number of original features are also included, such as the snug, the interior gaslighting, as well as wall-mounted historical memorabilia including a photograph of the American poet John Berryman taken with Jack Ryan, the 1967 painting of the original street parade that hangs over the fireplace, and an 1813 document relating to the pub's Guinness account, which remains in operation today. An interesting external feature is the cast-iron gas lamp, featured in the 1967 painting, which was reinstated in its original position immediately in front of the new building.

48. The Swan, No. 58 York Street

The Swan pub marks the corner of York Street and Aungier Street near the east side of St Stephen's Green. Its origins stretch back to 1661 – a remarkable level of continuity. In 1897 the current building was completed by Thomas F. O'Reilly. He traded in wine, beer, spirits and grocery provisions and gave the pub the Swan name. The Swan name was based on an ancient heraldic image and a mosaic image of a swan decorates the floor of the entrance doors. In 1937 the Swan came into the ownership of the Lynch family – an interest that lasts to the present. During the Civil War, following the War of Independence, the Swan building was occupied by the Republican forces. The building was attacked by the newly established Free State Army and a wall-mounted photograph of around 1923 shows the building pockmarked with bullet holes from the attack. The Victorian-style Swan building is four storeys high and curves around the corner site. The black-rendered ground-level pub front has the entrance on the curve of the corner and a sequence of large windows set between slim double pillars, with a continuous ornate fascia extending around the corners. Overhead, the floor levels are marked by tall curve-headed windows with blank openings at the corner, above which the roofline is marked by an ornate cornice. The pub interior has three elegant sections, one leading from the other. Here the outstanding feature of the pub is the remarkable level of skilled Victorian joinery work on display. This includes the polished granite-topped and panelled counter, the back bar with shelving and drawers, circular panels, mirrors and classical embellishments, as well as the elaborate glazed bar dividers and framed wall panelling.

One of the owners, Sean Lynch, was a noted rugby player who grew up over the bar, then owned by his father John Lynch. He played rugby for St Mary's College in Rathmines where he went to school, and later played head prop for Leinster. He was capped for Ireland fifteen times between in 1971 and 1975 and toured New Zealand with the British and Irish Lyons in 1971. There they were the first Lyons team to beat the All Blacks in 112 years. To mark this connection, Sean's rugby jerseys have been framed and displayed on the wall of the pub. Other images displayed include advertising mirrors and photographs.

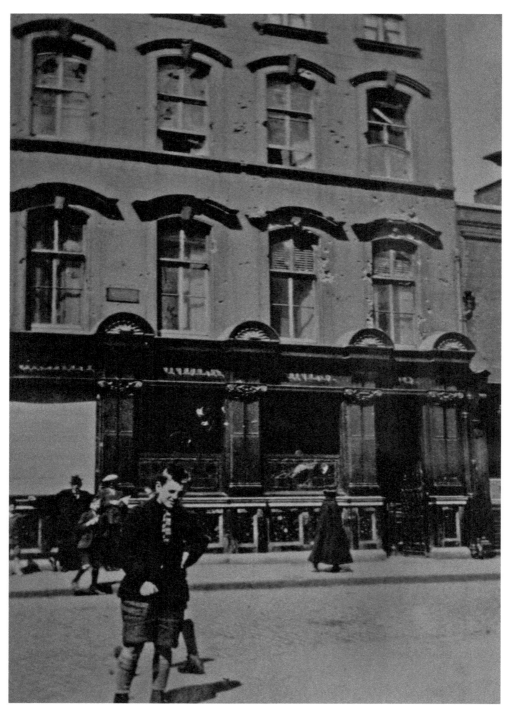

The front of The Swan pub, 1923. This shows the extensive bullet marks on the wall that resulted from the fighting between the Republican and Free State forces during the Irish Civil War.

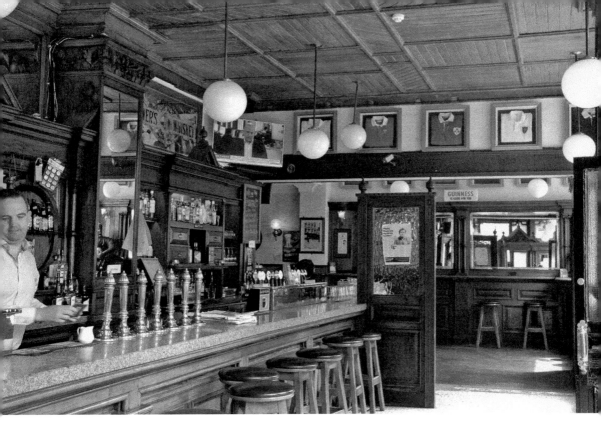

The crafted interior of The Swan pub including the wooden counter, back bar, bar dividers, and ceiling as well as the mosaic floor.

49. James Toner, No. 139 Lower Baggot Street

Toner's pub is positioned on the corner of Lower Baggot Street and Roger's Lane, where Andrew Rogers operated as a grocer and wine merchant between 1818 and 1850. Following this there were several owners, including William Drought in 1859, John O'Neill in 1883 and James Grant in 1904. James Toner held the ownership between 1923 and 1970. Joe Colgan took over the pub in 1970, followed later by the Dunne and Quinn families. The pub takes up the ground floor of an eighteenth-century house with the continuous Victorian pub front wrapping around the street corner. The Baggot Street front has a pair of plate-glass windows, a moulded fascia with the name 'James Turner' and a corner doorway. Overhead, the continuous moulded fascia extends across both faces of the front with bracketed globe lighting overhead. Underneath, the Roger's Lane fascia and globe lighting is a large colourful advertising panel with the name 'James Toner'. The pub's Victorian interior is divided into individual sections by a sequence of framed timber partitions and counter dividers with mirrors, with the similarly framed snug just inside the door. The current owner, Mick Quinn, sees the pub as a museum, with a rich collection of historic elements including stock drawers behind the counter, brass taps, stone flooring, wall mirrors, old advertising panels and glazed display cabinets filled with curios relating to historic pub life. There is a newer section at the rear as well as a spacious beer garden.

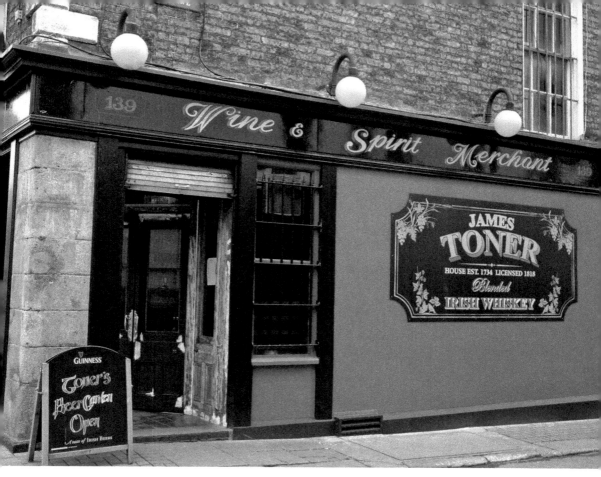

The corner wrap-around pub front of Toner's pub has plate-glass windows, corner doors, a painted wall sign, a continuous moulded fascia and overhead globe lighting.

The interior of the pub was used in a scene from the 1971 film *A Fistful of Dynamite* staring James Coburn and Rod Steiger.

During the 1920s the poet William Butler Yeats took up residence in Dublin. He mentioned to fellow poet Oliver St John Gogarty that he had never been in a pub, whereupon Gogarty offered to introduce him to the Dublin pub life. The pair visited the pub and were seated in the snug, where they were served their glass of sherry. After he had sipped his sherry Yeats stood up and said to Gogarty, 'I have now seen a pub so would you kindly take me home.' The pair then left the premises much, apparently, to the relief of Yeats.

The Victorian interior of Toner's pub is divided into sections by a sequence of framed timber partitions and counter dividers.

50. The Wellington, No. 1a Baggot Street Upper

The Wellington is a small pub positioned on the corner of Upper Baggot Street and Mespil Road, the site of the medieval Baggotrath Castle. The castle was built in the thirteenth century by Robert Baggot and survived until 1649 when it was partially demolished during the Battle of Rathmines. A painting of the ruin by Captain Francis Grose in 1792 shows the castle walls partially intact. The ruin was completely demolished during the nineteenth century by the City Corporation to facilitate the laying out of Upper Baggot Street. The current corner pub building dates from around this period and consisted of a three-storey house with the pub inserted at ground level some time later. A photograph of the pub taken from the Grand Canal bank around 1900 (before it was built over) shows the elaborate Victorian pub front with decorated uprights, plate-glass windows, a corner doorway and overhead fascia as well as some passing horse-drawn carriages. Today the pub front shown in the photographs has been replaced, although the Victorian design has been retained. This includes the usual uprights, the named fascia, small windows and central doorways on Lower Baggot Street and Mespil Road. Over the years the pub has gone through a number

of ownerships and changes in name, including the Crooked Bobby and G. F. Handle. When the pub was recently bought by the current owner the vendor wanted to impose a yearly licence fee for the use of the name G. F. Handle. The purchaser would not agree to this and instead renamed the pub the Wellington after the nearby Wellington Road. Internally, the pub has a single cosy room on two levels, with wooden flooring, polished bar joinery, wall-mounted memorabilia, the 1900 photograph and the embossed ceiling.

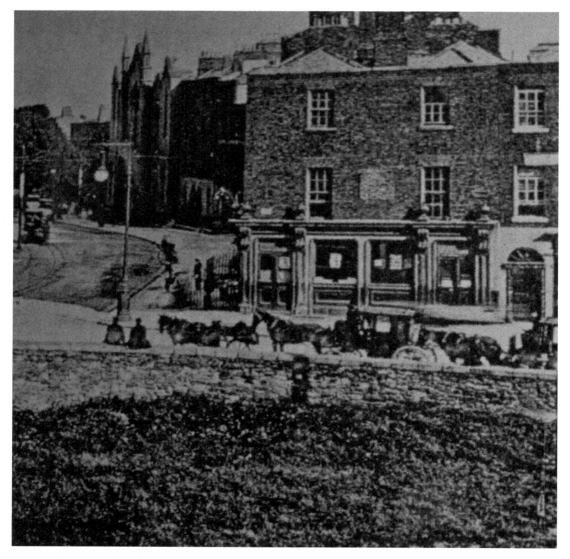

A photograph of The Wellington pub facing onto Mespil Road with its elaborate shopfront and passing horse-drawn carriages, taken from the Grand Canal bank around 1900.

The cosy interior of the Wellington pub has polished joinery, wall-mounted memorabilia and an embossed ceiling.

About the Author

Pat Dargan is an architect and planner by profession and lectured in physical planning and design. He has a special interest in the heritage and development of towns and villages and he has published and lectured internationally.

Also by the author:
Exploring Georgian Dublin (2008)
Exploring Ireland's Historic Towns (2010)
Exploring Irish Castles (2011)
Exploring Celtic Ireland (2011)
Exploring Georgian Limerick (2012)
Georgian Bath (2012)
Georgian London: The West End (2012)
The Georgian Town House (2013)
Edinburgh New Town (co-authored with Carley, Dalziel and Laird, 2015)
Dublin in 50 Buildings (2017)
Bath in 50 Buildings (2018)